IMAGES
of America

EDISTO ISLAND
A FAMILY AFFAIR

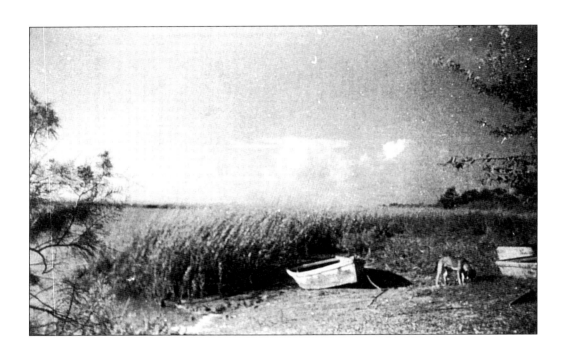

IMAGES
of America

EDISTO ISLAND
A FAMILY AFFAIR

Amy S. Connor & Sheila L. Beardsley for
Edisto Island Historic Preservation Society

ARCADIA

First published 1998
Reprinted 1999, 2000, 2005

Published by Arcadia Publishing
Charleston SC, Chicago IL, Portsmouth NH, San Francisco CA

Printed in Great Britain

Library of Congress Catalog Card Number: 2004114468

For all general information contact Arcadia Publishing at:
Telephone 843-853-2070
Fax 843-853-0044
E-mail sales@arcadiapublishing.com
For customer service and orders:
Toll-Free 1-888-313-2665

Visit us on the internet at http://www.arcadiapublishing.com

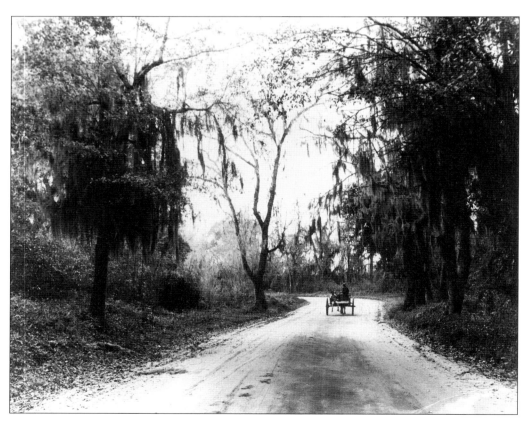

Contents

Acknowledgments

The Edisto Island Historic Preservation Society (EIHPS) is indebted to all of the past and present Island residents who so generously shared with us their treasured old photographs. These custodians of cherished family albums not only let us have access to their photographs, but they also gave freely of their time, answering our many questions, reminiscing, and repeating stories handed down from generation to generation. In many instances, if the person whom we telephoned did not know the answer to our question, the response was "I'll look it up and call you back."

The response to the EIHPS's request for photographs was so positive that only half of the offerings could be used as part of this book. However, all of the photos were copied and are now an important part of the records in the Museum archives. So, to each of you listed and to anyone we may have inadvertently overlooked, we extend our thanks.

Mary V. Allen, Arthur W. Bailey, Pinckney and William R. Bailey, Gale and Ritchie Belser, Caroline Pope and Jack Boineau, Donald David Dodge, Sarah Fick, Robert Godwin, Frank B. Hines Jr., John R. Jenkins, Florence Parks Johnston, Glenn Kudlevicz, Mary Johnstone Lantz, Harvie S. Lybrand, Bobbie Maguire, Jane Murray McCollum, Mary Francis Mead, Elizabeth Whaley Middleton family, Marian C. Murray, Betty Parker, Daniel Townsend Pope III, Jann Smith Poston, Margaret Holmes Robinson, Henrietta Seabrook Sanders, Myrtle Singleton, E.M. Skidmore, Jean Wilkinson Smith, Alice Bailey Stevens, Virginia Pendarvis Tavel, Ellen Holmes Wright. Other photos are used courtesy of Archivio Ugo Mulas, Milano, Italy; and Department of the Army, U.S. Army Military History Institute, Carlisle Barracks, Carlisle, Pennsylvania.

Introduction

It has been written that Robert Sanford and his party explored what is now Edisto Island in 1666. When the Lords Proprietors read his glowing account of the Island's beauties, fertility of the soil, and excellent climate, they financed a settlement which they called Locke Island, named for John Locke. Locke had helped the Proprietors draw up basic laws with which to govern any settlements made by the Proprietors. The settlement's name, "Locke," was discontinued after a period of time and was called after the Edistow Indians who lived on the Island during the summer months.

In 1675, the first deed on record of transfer of lands was made between the Edistow Indians and the Earl of Shaftsbury (represented by Andrew Percival) and the other Lords Proprietors.

Later, in 1682, another settlement was made on the Island by a colony of English who had attempted a settlement at Port Royal, a barrier island south of Edisto. Their attempt at settlement was jeopardized by hostile natives and by marauders from the Spanish settlement at St. Augustine.

The Spanish raided the Scottish and English settlements on Edisto in 1686—a grave setback for the plans of the Lords Proprietors, although efforts continued into the eighteenth century, and later colonies flourished.

In her research for a short history of the Island, lifelong resident Marion Seabrook Connor found the following early settlers mentioned in old South Carolina State records: John Jenkins arrived around 1706; William Edings came from Scotland with Lord Cardross and died on Edisto in 1712; Paul Grimball, born in England about 1645, died on Edisto in 1695. Grimball was deputy proprietor of South Carolina, and was secretary of the colony when Governor Morton held office. Robert Seabrook came to the Province before 1680 as commissioner under the Church Act of 1704 and was a member of the Assembly and Speaker of the House in 1705. His son, Joseph, was a member of the Assembly in 1721. Ephraim Mikell was appointed tax collector for Edisto in 1715. His son, Ephraim, was captain of the Regiment of Foot in the expedition against St. Augustine in 1740.

The success of the earliest plantation settlements depended in part upon peace with the native tribes, relief from Spanish raids, slave labor, and a money crop. Island planters tried growing rice, but found that the river and creek waters were too saline. Indigo was successfully grown until the English market for it dried up after the American Revolution.

The planters turned to Sea Island cotton. The success of the culture of long-staple silky cotton produced in the rich Edisto soil is a well-chronicled part of the Island's history. Its demise began with the loss of slave labor and ended with the advent of the boll weevil around 1920.

Edisto sons and fathers answered their country's call to arms in all its wars. Sacrifices were made in all of the conflicts, but by far the most devastating to a way of life was the total commitment made by them in the Confederate cause. Those who returned were greeted by sights of burned-down houses, ransacked and empty houses, no livestock, and desolate fields.

Stout hearts and indomitable spirits enabled the Edistonians to survive the terrible Reconstruction years, and many of their descendants are still living on the land so long cherished by their forebears.

Edisto is about families. The repetition and mixture of names through the centuries show the close-knit connections between Island families. Travel was more often between plantation homes than it was between nearby islands and towns, and this extended to travel in search of marriage partners. Young people looked for life companions among their Island neighbors—a practice which produced the Edisto "Family Affair."

One
The Islanders

Great fortunes were made by the planters of large acreage on Edisto Island in the first half of the nineteenth century. The families of these planters maintained a close relationship with each other, socializing, hunting, and worshipping together. Such propinquity produced many intermarriages. The planters encouraged their young people to marry within the circle of friends for many reasons, among them, a desire to increase their wealth or simply to retain land holdings.

The intermarriages produced an amazingly small mixture of names in the offspring. Babies were named for a forebear; the first son was given his father's name, and later boys were named for a very close relation. Girls' first names were most often the revered names from the Bible—Mary, Sarah, Elizabeth, etc. These baby girls most often had a surname for a middle name. Genealogies of the Islanders are difficult to sort out because of the repetition of relatively few family names. This section will introduce some of the faces that accompany the names.

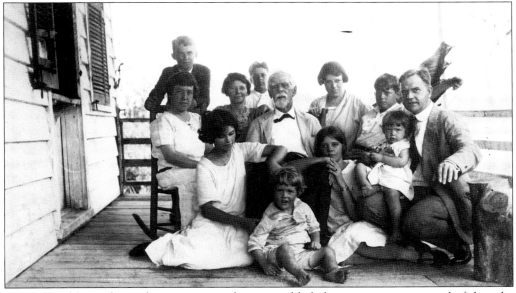

As a rule, sibling relationships were very close, most likely because it was expected of them by their parents just as their parents had expected it of them. As a result, large family gatherings were frequent, especially on the holidays. Here we see such a family gathering—that of the Townsend Mikell extended family at a cottage on Sunny Side Plantation.

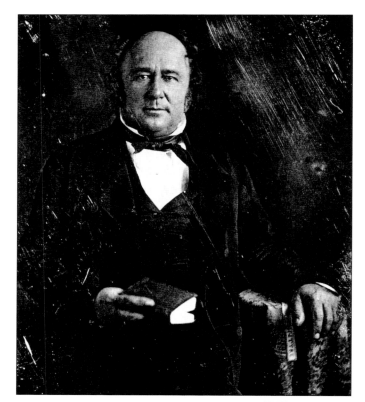

William Seabrook Jr. (1799–1860) was the son of William and Mary Ann Mikell Seabrook. He married Martha Washington Edings and built their home at Oak Island Plantation on West Bank Creek within sight of the North Edisto River, not far from where he grew up. This image was taken from an 1852 daguerreotype.

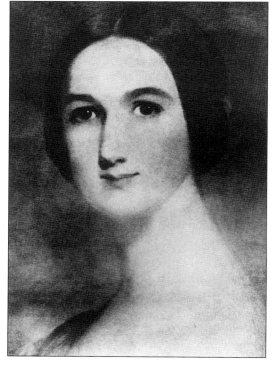

Carolina Lafayette Seabrook (1825–1878) was a daughter of William Seabrook and his second wife, Elizabeth Emma Edings. She was the half-sister of William Seabrook Jr. (shown above), and she married James Hopkinson and became the first mistress of the house at Cassina Point Plantation, a lovely setting also within sight of the North Edisto River. This is a photograph of a painting by famed artist Sully.

Schoolgirls Sarah Elizabeth Murray and Sarah Mikell Pope pose in the Seaside schoolyard. The buggies in the background were the "school buses" of that day. The horses and the conveyances waited until school was out to take some of the students back home.

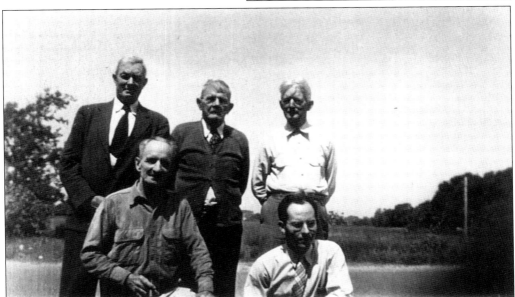

These men were at the post office when the photographer asked them to pose for this image. "Mail call" at the post office usually turned out to be a social gathering for the exchange of news, although telephones arrived on Edisto as early as 1904. Pictured are, from left to right, the following: (kneeling) MacGowan Holmes and Billy Hillis; (standing) Willie Bailey, Washie Seabrook, and Ed Sheeham.

11

This photograph is of Gertrude Bailey Woods, the daughter of Gertrude Stevens and William C. Bailey, in the late 1930s. The mother of a large family of sons, she returned to the Island after her retirement from teaching and the death of her husband. There she remained active in Trinity Episcopal Church as had her parents before her.

This is a daytime gathering of women at Cypress Trees Plantation. They are as follows: Lilla Murray Mitchell, Julia Paisley Mikell, Sallie Murray Pope, Mary Murray Spencer, Mamie Pope Murray, Lottie Nelson Pope, Julia Mikell LaRoche, and one unidentified.

This photo shows a family gathering to celebrate the 100th birthday of Mrs. Rosa Pope King on September 8, 1947.

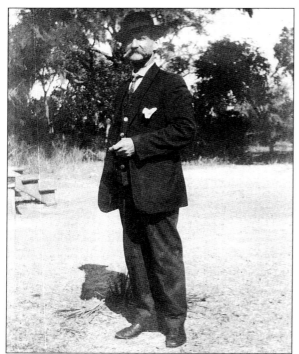

Cecil Westcott (1858–1942) was a self-taught artist who, during his lifetime, depicted on canvas the many varying scenes of marshes, waterways, and palmetto and live oak that are typical of the South Carolina Low Country, and especially this Island. His works are prized possessions in many homes here, as well as in homes of descendants in other places.

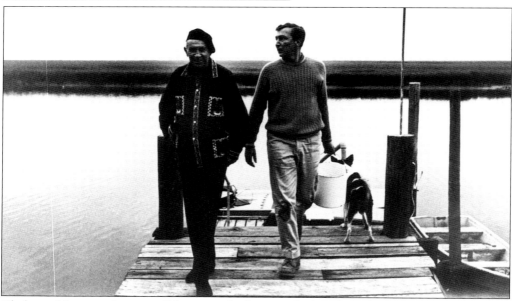

Chalmers Murray, a longtime Edistonian, had a great deal to do with preserving the history of Edisto Island. As a journalist writing for a Charleston newspaper, he wrote memorable articles about bygone days on the Island. Frequently, he included drawings by his wife, Faith Cornish Murray, to illustrate the pieces. He wrote several novels with settings in the place that he knew so well. In this photo he is pictured with the world-famous artist Jasper Johns (on the right) on a dock at Frampton's Inlet. Johns's house on Edisto became a retreat from the hectic pace of New York. (Photo copyright: Ugo Mulas Estate. All rights reserved.)

Longtime resident Faith Cornish Murray was another Island artist who depicted the beauty of marsh, tidal creeks, beach, and woodland through oils, watercolors, and other mediums. She and her husband, Chalmers Murray, lived on Frampton's Inlet at Jack Daw Hall.

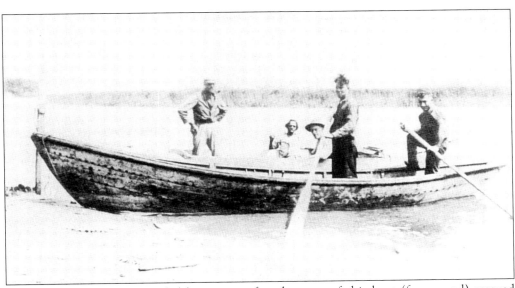

This action scene was recorded by camera after the crew of this boat (foreground) rescued sailors from a stranded ship. The boat in the background was the first powerboat on Edisto. Two of the men are identified as follows: standing on the left is Edward M. Bailey, and seated (with his hat on), Arthur W. Bailey Sr.

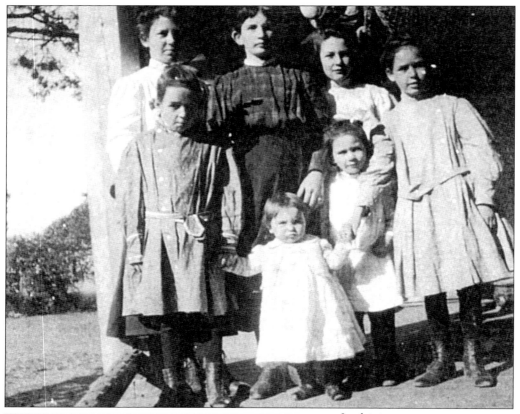

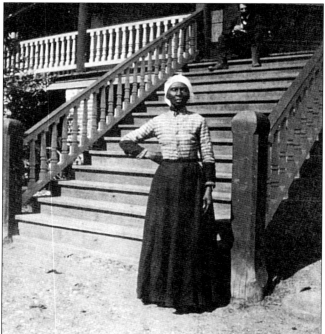

In this image are seven daughters of William Anderson and Amarinthia LaRoche Anderson on the porch of West Bank plantation house sometime during the first decade of the twentieth century. They were as follows: (front row) Ama, Fannie Lee, and Adele; (back) Marie, Alta, Edith, and Kathleen.

"Maum Clara," shown here at the bottom of the Cassina Point front steps, was the nursemaid for Ella and Addie, the two daughters of the J. Murray LaRoches during the late nineteenth and early twentieth centuries.

William C. Bailey (right) and his bride, Mary Gertrude Stevens (below), lived in the old Bailey residence on Point of Pines Road. For years Mr. Bailey operated a store on the corner of Highway 174 and Point of Pines, and the Baileys spent their lives on the Island. Although they left home for college and careers, their children always maintained close ties and a keen interest in what was happening to their hometown.

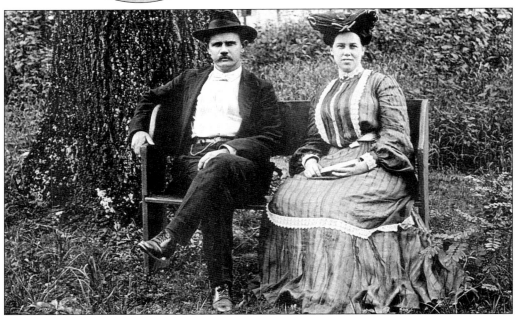

Pictured here is another family whose children attended the Edisto School, went off to college, careers, and marriage, but were drawn back to the Island from time to time to attend baptisms, graduations, marriages, and funerals of their old friends and the children of those friends. Mr. and Mrs. Edward M. Bailey pose with three of their children here. They lived at Blue House and later at Brookland Plantation.

Mr. and Mrs. George Washington Seabrook pose in the garden for a formal portrait. "Washie," as he was known, managed Seaside Plantation for owner Mr. McConkey in the early part of the twentieth century. Edisto Beach's Palmetto Boulevard is still known by old-timers as McConkey Boulevard.

This is a portrait of Jabez Westcott, father of Edisto artist Cecil Westcott. He lived at Mullet Hall and enjoyed a reputation as an inventor. He designed the Westcott Clevis, a device for regulating the depth of a furrow when plowing a field.

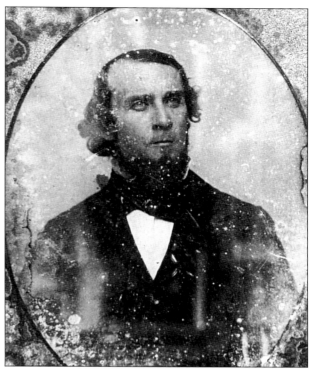

Alonzo Seabrook Bailey (1848–1919) of Blue House Plantation was married to Frances Douglas Legare in 1868. His grandfather, Donald McLeod, was a Presbyterian minister who served the Edisto church for over 20 years. A plaque on the wall of the sanctuary memorializes Dr. McLeod's service to the church.

Daniel Townsend Pope (1837–1909), born on Edisto Island in 1827 (although his parents lived on St. Helena Island), graduated from the Medical College at Charleston, South Carolina, in about 1860. At this time, he married Sarah Edings Mikell (shown below), and the newlyweds settled on St. Helena Island. Not long after, Yankee warships caused them to leave St. Helena in such haste that even their table silver was left behind. Dr. Pope served in the Confederate War. After the war, the Popes came to Edisto, starting with nothing, as the war had robbed them of all their possessions. He practiced medicine on Edisto for some 50 years. In March 1906, he lost his beloved wife, Sarah. The following year he married Miss Julia Smith of Georgetown.

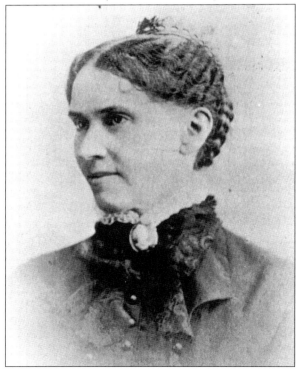

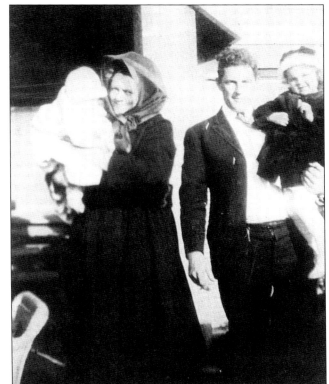

Mr. and Mrs. Winthrop Johnstone were the last residents of "Bleak Hall" before it was torn down. Here, the couple is pictured with their two daughters, Sarah and Mary, in about 1920. Below is a later photo with a view of the Bleak Hall Plantation house with the Johnstone's son, Francis, in the left foreground.

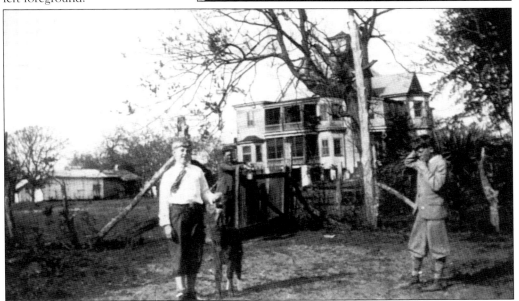

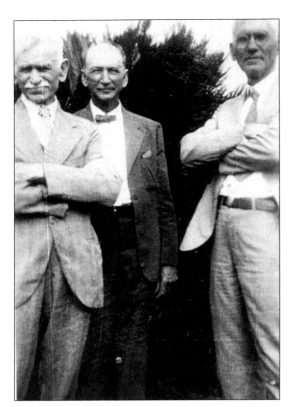

The second house to stand on the historic site of Governor's Bluff was home to these two Pope brothers: Daniel Townsend Pope and Dr. Jenkins Mikell Pope. They are pictured with John Girardeau Murry (in the center).

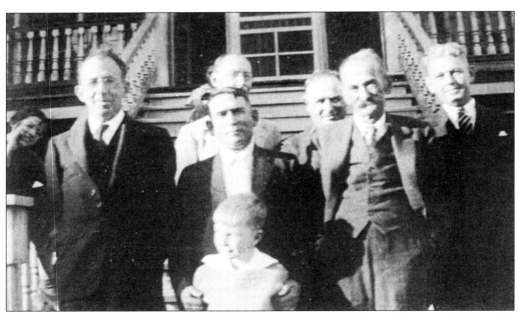

Standing on the steps at Cassina Point are, from left to right, as follows: (front row) William E. Seabrook III, Joseph L. Seabrook (holding unidentified child), James Hopkinson Jr., and Edings Blood; (back row) unidentified man and Richard James LaRoche.

Cora Richardson Mikell from Selma, North Carolina, was the second wife of Townsend Mikell of Peter's Point Plantation. They married on July 17, 1912. She was the sister of Dr. Jenks Pope's first wife, Rosa, mistress of Middletons Plantation.

These three Pope sisters grew up at Governor's Bluff Plantation. Mamie married Islander J.G. Murray II, Amarinthia married James Murray of Edisto, and Jenny married the Reverend Frank Allen from "off" (an Edisto expression to designate a person who was not born and reared on the Island).

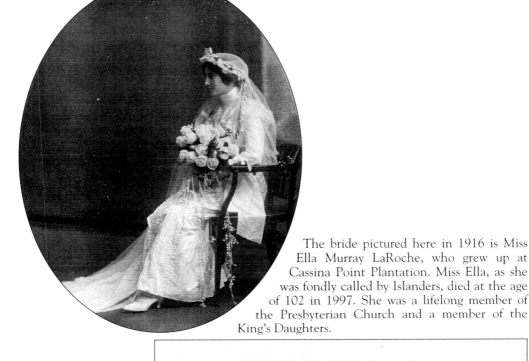

The bride pictured here in 1916 is Miss Ella Murray LaRoche, who grew up at Cassina Point Plantation. Miss Ella, as she was fondly called by Islanders, died at the age of 102 in 1997. She was a lifelong member of the Presbyterian Church and a member of the King's Daughters.

Mrs. J. Murray LaRoche

requests the honor of your presence

at the marriage of her daughter

Ella Murray

to

Mr. William Edings Seabrook, Jr.

on Thursday, December the twenty-eighth

nineteen hundred and sixteen

at high noon

Edisto Island Presbyterian Church

Edisto Island, South Carolina

Two

Their Dwellings

The antebellum plantation houses still standing on Edisto Island are a small fraction of the ones destroyed by fire, neglect, or Sherman's troops. The same is true of all of the districts of the Low Country. The barrier islands, isolated by marsh and water, lost fewer houses to the Federal troops than the more accessible inland districts.

There are about 15 old houses on Edisto that have survived the vicissitudes of time. These are in fair to excellent repair. Most of the owners who returned to their homes after 1865 found damaged houses with no furniture, broken windows, and leaking roofs. The artisans who could have repaired these ravages were busy trying to put their own lives back together after they returned from service in the war. The fact that these houses are still standing in spite of devastating hurricanes and even an earthquake is a tribute to the skill of the builder-artisans of the late eighteenth and early nineteenth centuries. These old houses were masterpieces of durable construction. Several of the old places were destroyed by fire, among them the Jenkins's "Brick House" and the one known as the "Tom Seabrook House" (c. 1740).

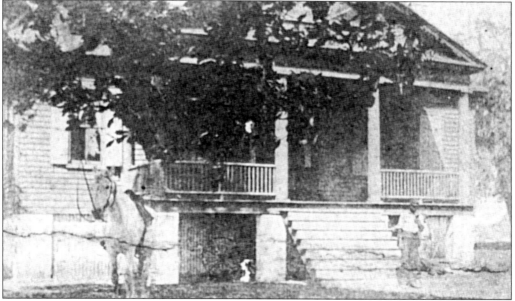

The dwelling shown here, known as "Old House," was once called "Four Chimneys." It is said to be the oldest house remaining on Edisto. The portico and dormer windows were added before 1850, and other improvements were completed sometime around the middle of the nineteenth century. Mr. and Mrs. Henry Frampton bought the old place in the late 1960s and spent several years restoring it to its present condition. Each year since 1986, the Edisto Island Historic Preservation Society has sponsored a tour of homes, churches, and historical sites. The tour provides an excellent opportunity to see four or five of the remaining antebellum houses.

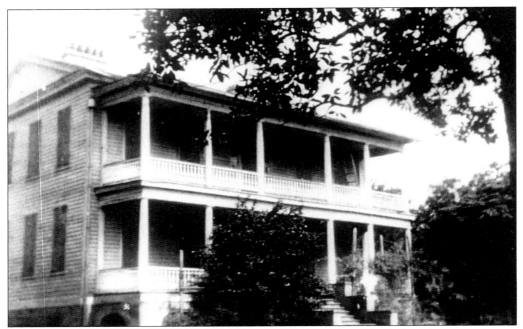

During the golden age of Sea Island cotton, Isaac Jenkins Mikell built his plantation house, "Peter's Point," on the banks of St. Pierre's Creek, *c.* 1840. In his book *Rumbling of the Chariot Wheels*, I. Jenkins Mikell Jr. writes about his boyhood and coming-of-age at the plantation. Today, the house is still standing, but unoccupied.

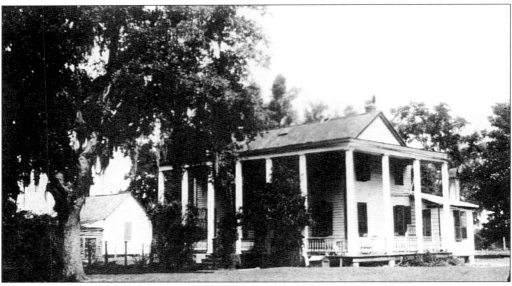

"Governor's Bluff" was built by Dr. Daniel Townsend Pope on property he acquired shortly after the Civil War. This gracious house is no longer in existence; it was replaced by a smaller house which still stands. The property is on Store Creek, also known as Governor's Creek.

The beautiful, original mansion was built on this site at Botany Bay by Daniel Townsend (1759–1842). It was to this mansion that Townsend brought his bride, Hephzibah Jenkins, in 1790. After the architectural gem was destroyed by fire, it was replaced by the structure shown here known as Bleak Hall. It was bought and torn down by a Dr. Greenway, who built a more livable residence on the site. A few of the outbuildings of the original Bleak Hall are on the National Register of Historic Places.

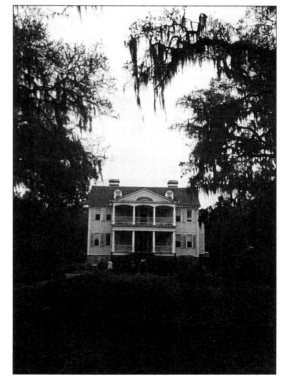

The William Seabrook house was built c. 1810 on Steamboat Creek. Information in the National Register of Historic Places credits the design of this mansion to James Hoban. The house was left unoccupied during the Civil War, and when the Seabrooks refugeed upstate ahead of Sherman's troops, it fell victim to marauding bands of scouts from the Federal Navy and Army. Later in the war, it was used to house Federal Army units. The house still stands, beautifully restored by Mr. and Mrs. David D. Dodge, who bought it in 1929.

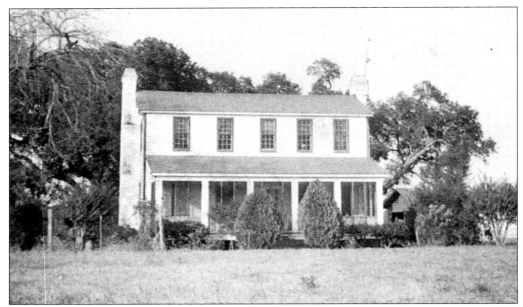

Blue House Plantation was located in the area between the Presbyterian Church and Steamboat Landing on a tributary of Steamboat Creek. It was the home of Mr. and Mrs. Alonzo Bailey during the late 1800s. This image shows the house as it appeared in 1957.

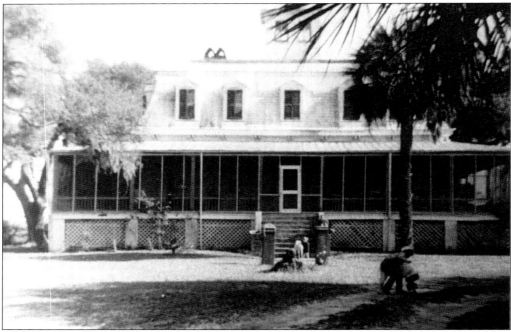

Sunnyside Plantation house was built *c*. 1880 by Townsend Mikell, one of the sons of I. Jenkins Mikell of Peter's Point Plantation. The unusual cupola is almost obscured by the palmetto frond. The cannon in front of the steps is said to have once been mounted on a pirate ship which anchored near Bay Point on the South Edisto River. It was discovered by workmen gathering oyster shells for the tabby foundation of this house.

This is "West Bank" house, located on the creek of the same name. It was originally one of the Hopkinson houses later occupied by Mr. and Mrs. William Anderson at the turn of the century and into the early 1900s. It stood on land that was part of the Cassina Point acreage.

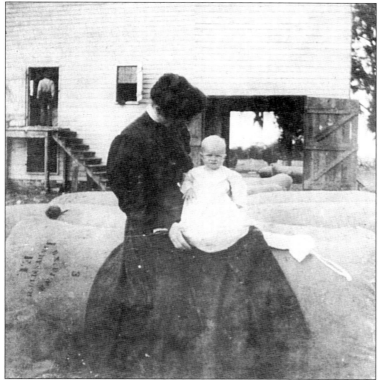

The building in the background housed the cotton gin at Middletons Plantation. Seated on one of the large bags of cotton yet to be baled is Amarinthia Pope Murray, holding baby Rosa.

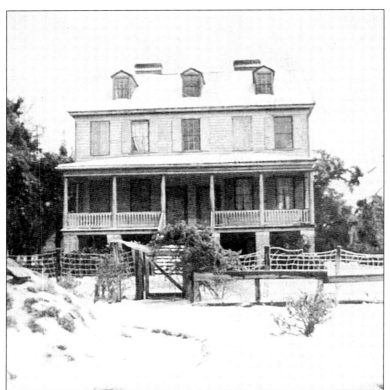

Cassina Point house is pictured here in a scene that is quite unusual for a South Carolina Sea Island. It depicts the "big snow" of 1914—a memorable event! The house is now a bed and breakfast where guests can enjoy a glimpse of Sea Island life as it once was lived.

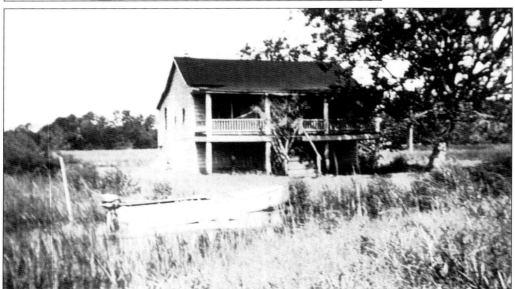

When Highway 174 was paved and rerouted in 1940–41, a small part of the William C. Bailey property at Point of Pines Road was cut off from the main body. On it stood a building which housed a cotton gin. When the need for a cotton gin disappeared around 1920, the building was torn down and the lumber used to build this cottage. It was directly across the street from the old post office, but is no longer standing today.

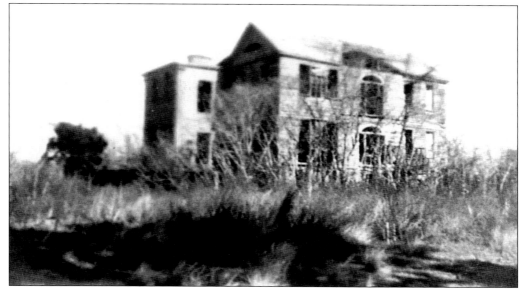

Sea Cloud is said to have been one of the most beautiful houses on the Island. After it fell into disrepair, it was torn down and never rebuilt. This image was taken during its last days. Especially notable about the interior was its magnificent spiral staircase.

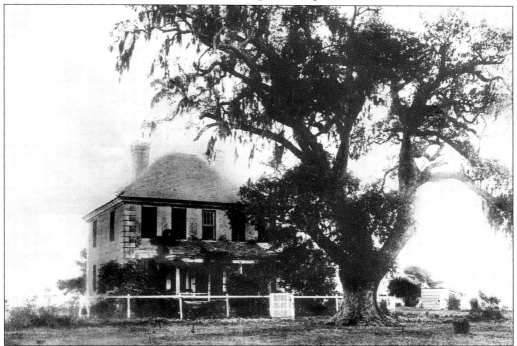

Brick House, pictured here before it burned in 1929, was built by Paul Hamilton, c. 1725. Hamilton built this manor house, he said, "to get away from the pirates" who had been marauding his first Edisto house at the mouth of the North Edisto River. The picturesque ruins of Brick House and the land surrounding it remain in the Jenkins family as they have for generations.

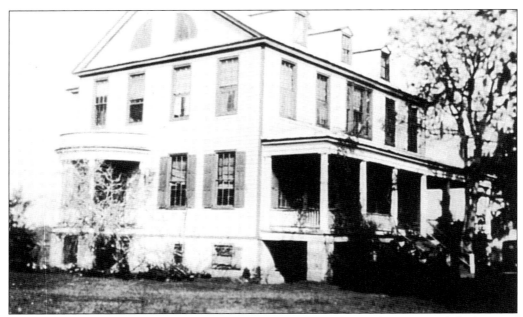

The house at Oak Island Plantation was built in 1828. Since then, it has remained the home of the Seabrooks and their descendants, except during the Civil War period when Federal army troops were quartered in the house.

Before the devastating 1893 hurricane destroyed Edingsville Beach, planters summering at the beach returned each day to take care of their farming operations on the Island. Upon their return to the beach each day, they stopped at this "Half-Way House" for refreshments. The building still stands, but it no longer fronts on the main road. Highway 174 was re-routed and now runs behind the house.

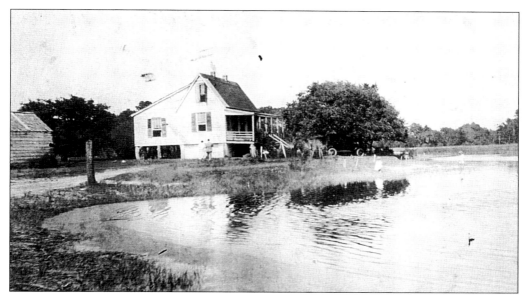

This cottage has an interesting history. At one time it was one of the houses that made up the village of Edingsville Beach. Luckily, before the notorious hurricane of 1893, it was moved intact on mule-drawn flatbed conveyances that were used for hauling cotton. The mover was Dr. Woodruff, a physician who visited the Island when called by the head of an extended family to care for family members in need of treatment.

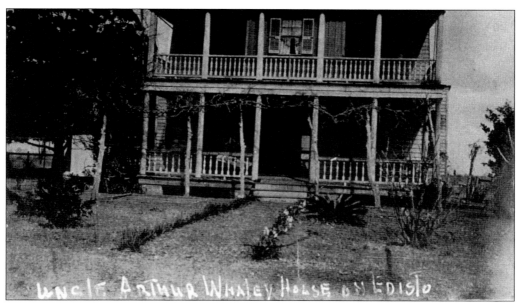

The owner of the original image of this scene remembers visiting "Uncle Arthur Whaley" at this house. She said that it was known as the Tom Seabrook House, but was home to four or five generations of Whaleys. The Carolina Arts Association publication, *Plantations of the Carolina Low Country*, with text by Samuel Gaillard Stoney, rated this house as the second oldest on Edisto Island (after Brick House), being built about 1740. It was destroyed by fire in 1944.

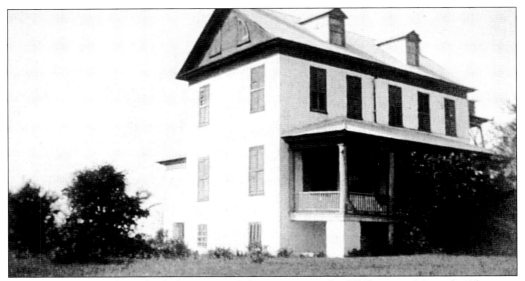

Seaside Plantation was deeded to Mary Edings in trust for William and Joseph Edings in September 1786 (11 years after the Independence of the United States). The Federal style plantation house was built *c*. 1810. Originally known as Locksley Hall, the house has 12-foot ceilings and three stories. It is on the National Register of Historic Places.

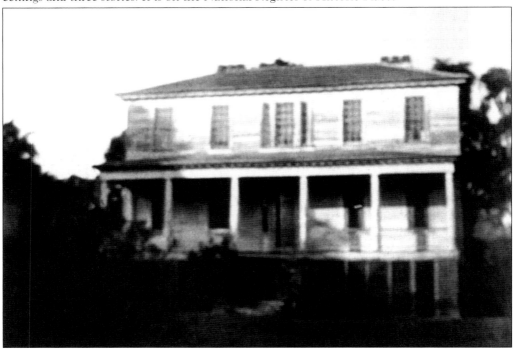

Prospect Hill was built in the late eighteenth century by Ephraim Mikell Baynard. It stands on land adjacent to the South Edisto River, well preserved but unoccupied. According to Dr. Chalmers Gaston Davidson in his meticulously researched book, *The Last Foray*, Ephraim Baynard was such a prosperous planter that he bequeathed $160,000 to the College of Charleston. Fortunately, the bequest did not become effective until after the Civil War.

The Hutchinson House was built on land known as the Shell House Tract. This property of 404 acres was deeded to James Hutchinson, who built the house for his bride in about 1880, following the Civil War. The sawn trim on the house is particularly notable. James Hutchinson was an important leader in the black community after the Civil War. He chaired a mass meeting of Edisto blacks organized to request that Governor Scott make land available for division amongst the freed blacks.

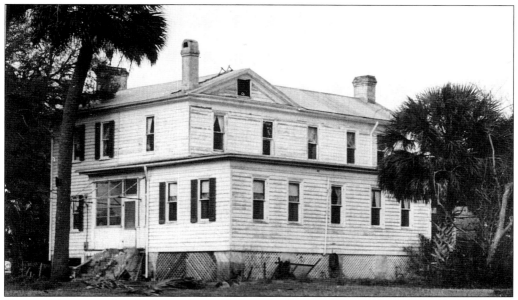

Cypress Trees was first built in about 1830 on land owned by A.J. Clark. It went through extensive renovations, and additions were made in the twentieth century. Susan J. Clark married Dr. Joseph J. Murray, and the house remains in the Murray family to this day. After the Civil War, the Murrays re-established their farming pursuits at Cypress Trees.

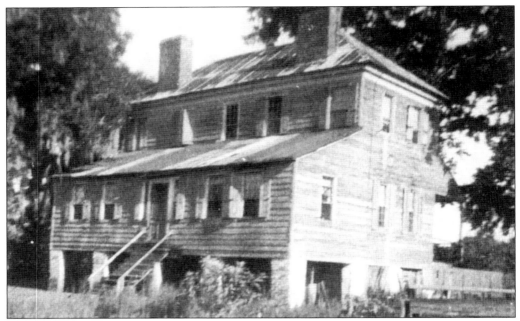

It is thought that Frogmore was built around 1820 for Dr. Edward Mitchell and his wife, Elizabeth Baynard. The location of the house away from a navigable waterway was unusual on Edisto. However, it is located on an important roadway—Pine Landing Road—which received considerable traffic making its way to and from the landing at the South Edisto River. Mr. Arthur Bailey, a descendant, and his wife live at Frogmore today.

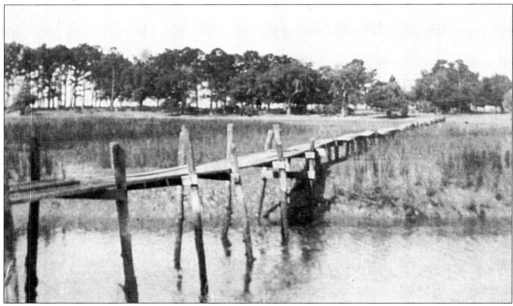

During a period of time when Adelaide Seabrook lived at Cassina Point and her sister Ella Seabrook lived at Oak Island, a narrow footbridge over two "gutters" and a wide expanse of marsh connected the two properties. A trip on foot across the bridge took less time than a drive around by road. This ingenious piece of construction was used until sometime in the late 1940s.

Three
Hope for the Future

Before medical science discovered lifesaving immunizations and miracle drugs, infant and child mortality soared. Although eighteenth- and nineteenth-century birth rates per family were very high, the death rates among infants and the very young were also painfully high. Only the hardiest of them grew to adulthood.

The images in this section are of children who were born and reared on the Island. The boys among the earliest ones, as a rule, left Edisto for their college educations, but did so with full expectation of returning home to work with their planter fathers. When the boll weevil put an end to the large-scale production of Sea Island cotton in the early 1920s, many of the sons did not return home after college. They sought work where it was available.

During the nineteenth century, girls were tutored at home and expected to stay there until they were married—most often to another Islander.

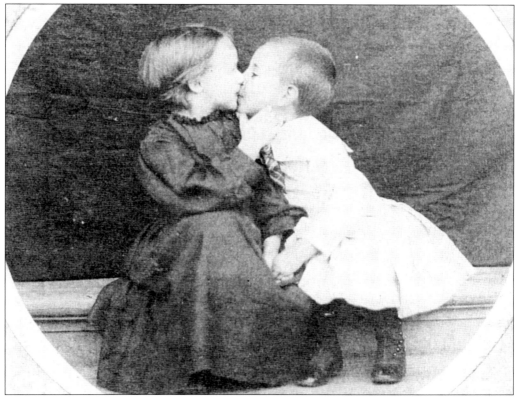

Dates were not available for all of the images in this section, but the reader can look at the styles of clothing and get a general idea of the period of each costume. This charming photo of kissin' cousins shows Eliza Reid Bailey and William E. Seabrook.

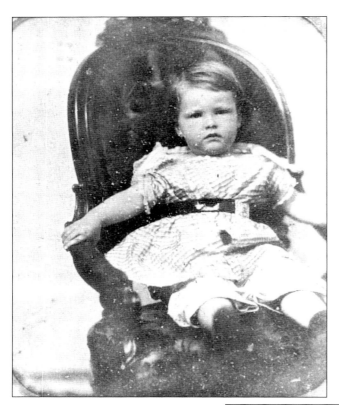

This young fellow, Cecil Westcott, grew up to be a well-known Low Country landscape artist. Many of his paintings are hanging in houses on the Island today.

John Cornish Wilkinson and his brother, Frank Alston Wilkinson, were born in the 1890s at Sea Cloud Plantation. Frank grew up to be a Charleston County lawman. After he organized a baseball team at the Edisto School in the 1930s, he became known as an unofficial coach as well. When the Civilian Conservation Corps camp was established at Edisto Beach in the 1930s, he voluntarily organized sports activities for the boys stationed there.

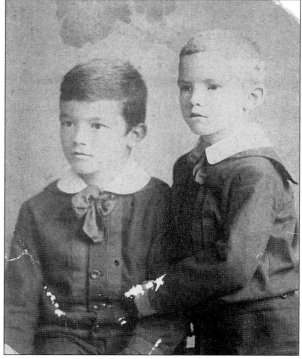

Francis and Julie Hopkinson are the grandchildren of the first residents of Cassina Point, Mr. and Mrs. James Hopkinson. They grew up on Edisto, and although they moved away in adulthood, they always maintained close ties with their home place.

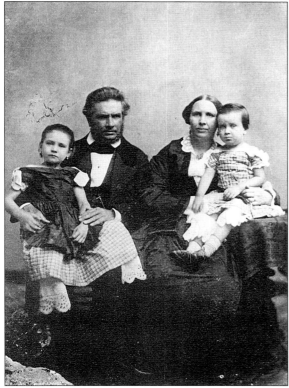

Pictured here are William Meggett Murray (1806–1866) and his second wife, Martha Swinton Caroline Murray (1820–1894), and their children Caroline and Thomas Chalmers. The photographic process that produced the original of this image was a variation of the daguerreotype called ambrotype. It is unusual to find photos of that period as clear as this one because exposure time was very long and young children had difficulty maintaining the motionless pose for the required length of time.

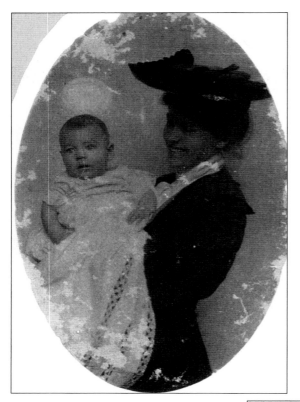

No date was given for this image, but judging by the outfit worn by the lovely young mother, one might guess it was produced in the second decade of the twentieth century. Here, Mary Mellichamp Johnson Stevens shows off her son, Stanyarne Stevens.

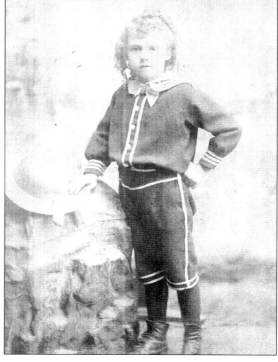

This studio portrait shows the young William Charles Bailey (1883–1949), who grew up to be the proprietor of a much-patronized store on Edisto. He sold the items most needed by his neighbors: food, dry-goods, kerosene for lamps, and later, gasoline for the first automobiles. Because the post office was, for a time, located inside the store (and later, just next door), it became a daily gathering place for Island residents.

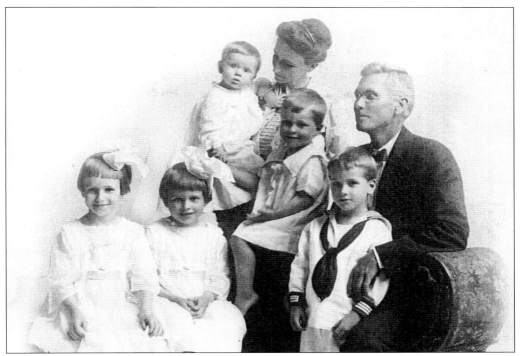

Dr. and Mrs. (Charlotte Nelson) Jenkins M. Pope are seen here with Charlotte, Sally, Billy, Jenks, and baby Townsend. All of these children grew up at Middletons Plantation. All but one spent their adult years away from Edisto, but they always maintained strong ties with home.

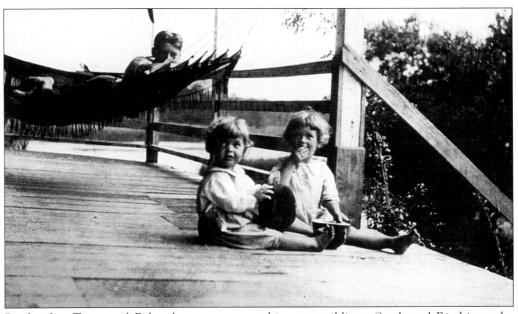

Big brother Townsend Belser keeps an eye on his young siblings, Sarah and Ritchie, as he relaxes in the hammock. The setting is the porch of a cottage at Sunnyside Plantation with a view of salt marsh and tidal creek.

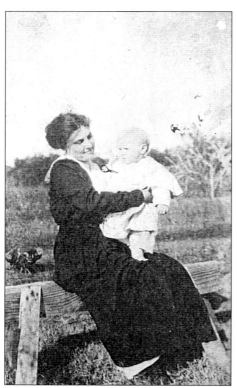

Violet Westcott Wilkinson, wife of Frank Wilkinson, holds their daughter, Jean, here in about 1919. It is because of this child that today we enjoy the live oaks that form a canopy in places along the old King's Highway. When she grew up, she became engaged to the man who engineered the paving of the highway and told him that if he cut any of the live oaks down she would break off the engagement.

An auspicious social occasion is being celebrated here on the piazza at Cassina Point. The festivities mark the first birthday (in January 1919) of Parker (left) and Adelaide (holding her doll). The two honorees were cousins and neighbors whose homes were separated by a tidal creek and a marsh.

Townsend Mikell is helping his daughter Susalee get astride for a ride. The house in the background was not identified.

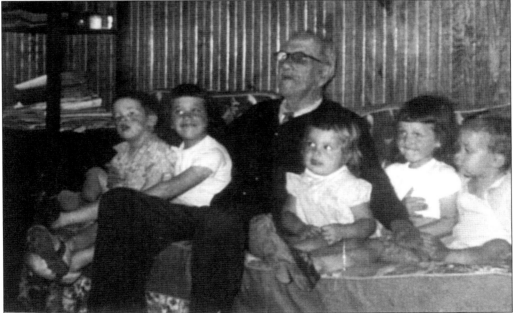

This is E. Mitchell Seabrook posing with five of his great-grandchildren in the living room of his cottage at Edisto Beach. With him, from left to right, are Kip Connor, Kathy Connor, Betsy Neely, Bunky Connor, and Robby Johnson.

William Robert Bailey, the son of Mr. and Mrs. William C. Bailey, is pictured here in an image from 1914. He was one of the Islanders who served in World War II. He married an Islander whom he had known through most of his growing-up years.

Cypress Trees Plantation is the setting for this image of Peter Mike holding the hand of young John "Gerry" Murray IV on a rare, very cold day on this Sea Island.

This young lady sitting with her four-legged friend near the front steps of the second Bleak Hall is Mary Rutledge Johnstone, daughter of Mr. and Mrs. Francis Winthrop Johnstone, *c.* 1914.

The second Bleak Hall is also the setting for this charming image. Dan Stevens is seen here with Sarah Johnstone, the second daughter of Mr. and Mrs. Winthrop Johnstone.

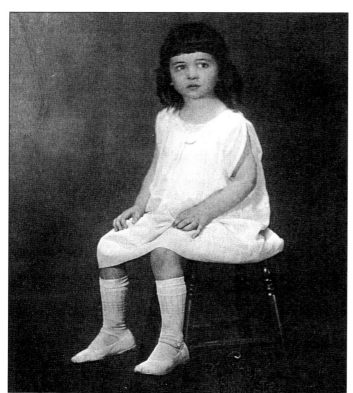

Julia Hopkinson Seabrook, born in 1920, posed patiently, but not very happily, for a studio portrait when she was four years old. She was the daughter of Mr. and Mrs. William E. Seabrook III.

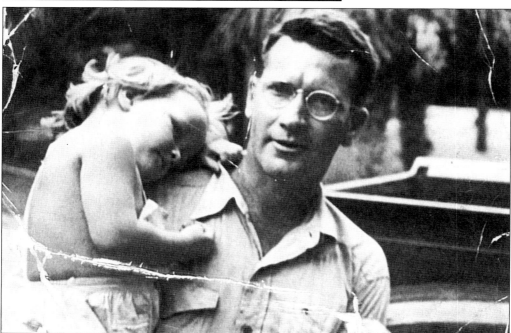

Jenkins Mikell Pope Jr. grew up at Middletons Plantation with two brothers and four sisters—a very real "family affair." Here he is seen holding his daughter Virginia in 1951.

Four
Island Life

Life on South Carolina's sea islands is slow-paced and somewhat leisurely, much more so in the past than today. Before the arrival on Edisto of the telephone, electricity, and the Dawho Bridge, residents provided their own amusements. Finding pleasure in each other's company, the Island social life thrived. Informal chance encounters at the one Island store and at the post office were occasions to exchange news.

The after-service gatherings in the churchyard were prolonged affairs because it was a time when men talked politics and, since most of them were farmers, weather. The women exchanged news about their grown children away at college or working at a job "off-Island." In the days when backyard vegetable gardens flourished, the ladies talked about their summer canning efforts. Nowadays, the talk is about produce preserved in the freezer.

Older Edistonians were nostalgic about the days gone by and the good times that people enjoyed here in their isolated Island community.

This is Willie Bailey standing in front of the post office, which was in the same building that housed his store but with a separate entrance. "Mr. Willie" was the mail carrier for 38 years and was well known by one and all.

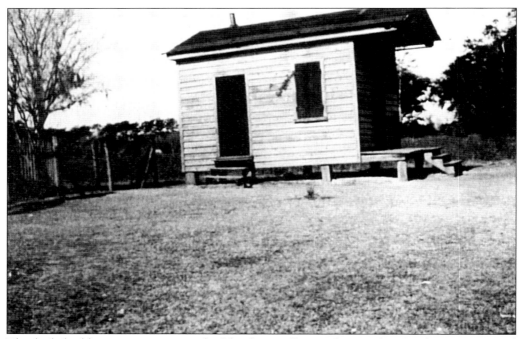

This little building was at one time the Island post office, and it stood in Cecil Westcott's yard near Store Creek. The extended roof overhanging the porch is reminiscent of slave-quarter houses, of which there are very few remaining on Edisto.

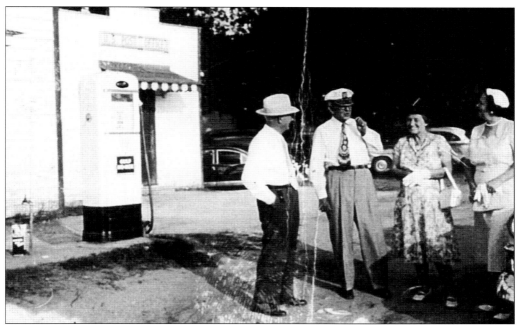

Four Islanders catch up on news in front of the post office and gas pump at "The Store"—a common sight on weekdays and Saturdays at the time when the mail had been "put up." As with gatherings at the churches on Sundays, one of the pleasures on Edisto has always been meeting other Islanders at the post office.

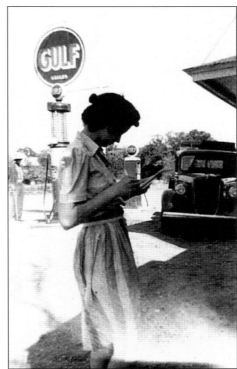

Ellen Holmes is pictured here reading her mail in front of Bailey's Store in 1942.

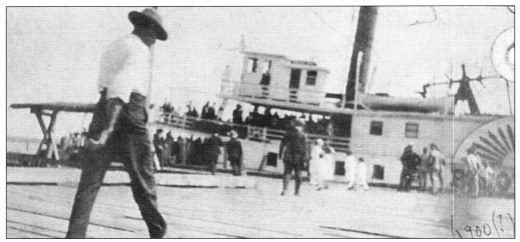

The *Pilot Boy* waits at the dock for passengers. Before the Dawho Bridge crossed the river, Edistonians traveled off the Island by either the *Pilot Boy* or the *Mary Draper*. They would catch the boat at Steamboat Landing, sail to Yonge's Island, then catch a train and travel to Rantowles, and then to Charleston on the big train that came up from Savannah. Islander Jane Murray McCollum remembers that the men of the family would shop for the women in town, bringing back to Edisto fabric and patterns for the women to make clothes. The men would also bring household furniture, often, she recalled, "dreadfully uncomfortable and without style."

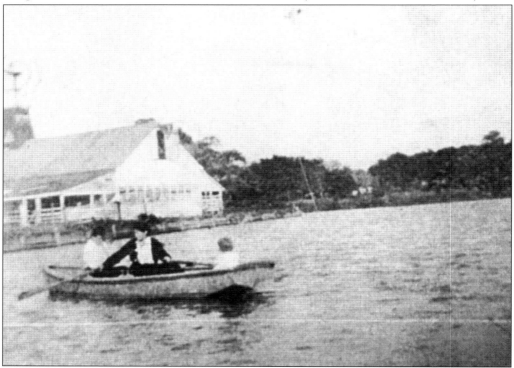

A family enjoys boating in an off-shoot of Store Creek. The Sunnyside barn and windmill are visible in the background. In the far distance is another one of Sunnyside's buildings, possibly the house.

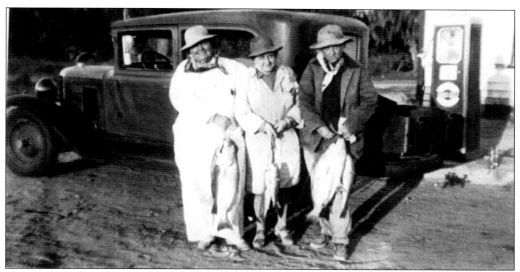

In the days before Edisto Beach was "discovered" by the general public, it was a paradise for fishermen and seashell collectors. These three ladies from Charleston show off their day's catch in front of Bailey's Store. They returned often to the beach to enjoy their favorite sport.

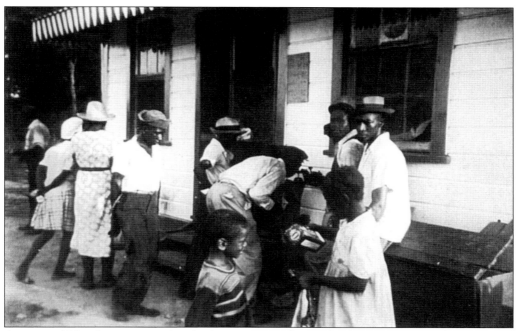

A group of Islanders enjoy each other's company in front of "The Store." Over the years, this scene was repeated hundreds of times, from generation to generation. Since it began, the store has changed hands and become a gathering place for visitors browsing for gift items.

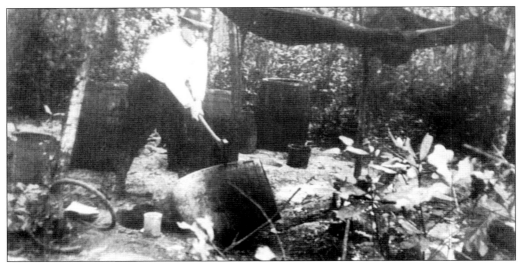

Edisto's acres and acres of heavily wooded land with dense undergrowth offered the requisite seclusion for the brewing of bootleg whiskey in days gone by. Charleston County lawman Silas Welch, whose "beat" included the Island, is seen in this image "bustin' up" a still. The bootlegger was accustomed to losing stills in this manner, usually managing to set up another in a new location.

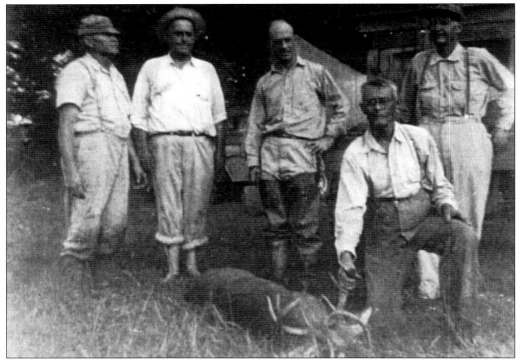

Arthur Bailey Sr. is the second hunter from the left, while Mr. Perry stands at the right, and Admiral Murphy is kneeling to show off the group's prize buck. The deer population has grown in recent years, and on certain sections of Highway 174, they create a night-time driving hazard. The other two men are not identified.

Mr. MacGowan Holmes, the first permanent resident of Edisto Beach, was the first commodore of the Edisto Yacht Club. He was a sailing enthusiast who taught young Islanders how to sail and, in the process, taught them to use the correct nautical terms when talking about the sport.

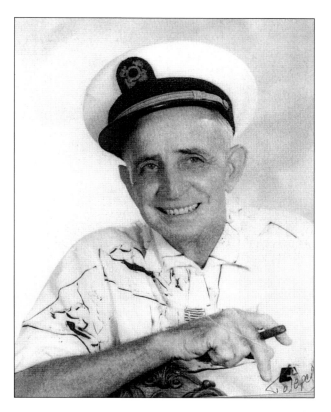

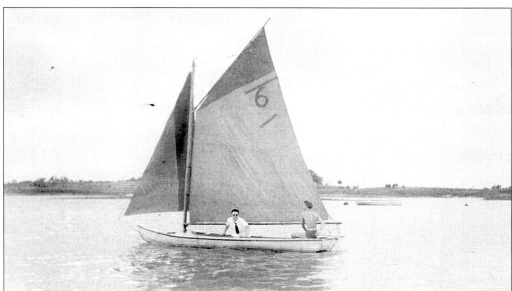

Because of the proximity of rivers and ocean, Edistonians became very good sailors. Here we see a typical sailing boat getting a workout, perhaps in preparation for the Rockville Races. One old-timer recollected the races with intense pleasure saying, "Our calendar year was always dated by 'before' or 'after' the Races." Note the formal necktie on one of the sailors.

The first Saturday in August was the day of the Rockville Races held on the North Edisto River. Islanders looked forward to this event with much anticipation. This image was taken on a boat as it made its way across the North Edisto to Wadmalaw Island where the village of Rockville is located. Among the passengers are young Ben Hunter, Pinckney Bailey, Adelaide Seabrook, and E.D. Hunter Jr. (standing).

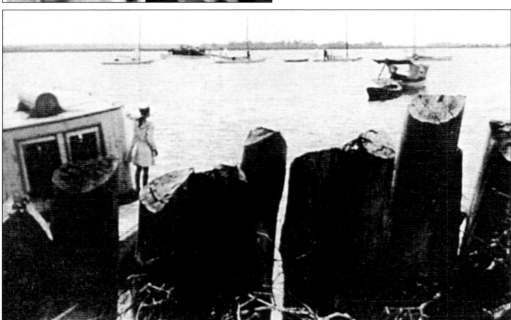

Regatta spectators arriving by watercraft tied up their boats in Bohicket Creek and watched the races from that vantage point. Almost every known type of craft was represented. Several types are shown in this image.

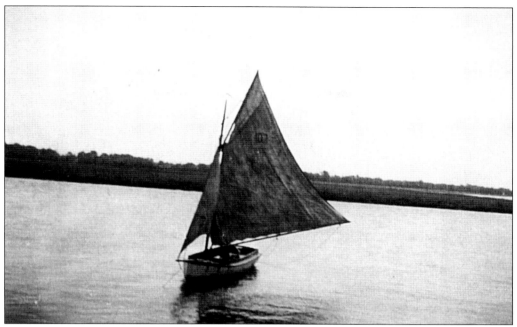

St. Pierre's Creek furnished safe anchorage for this sailboat. The view from its deck is typical of so many locales on all sides of the Island. The mouth of this creek is on the South Edisto River.

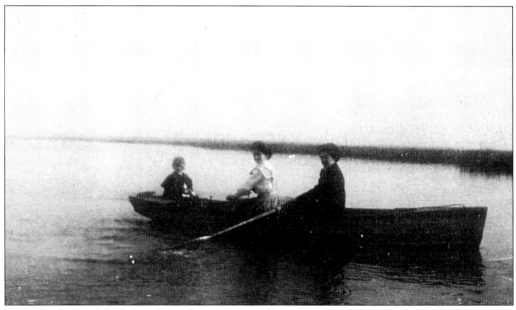

West Bank Creek is located on the opposite side of the Island from St. Pierre's Creek. The boaters seen here enjoying a rowboat ride probably left from a dock at West Bank Plantation. The creek forms a large horseshoe at that point and its mouth is on the North Edisto River.

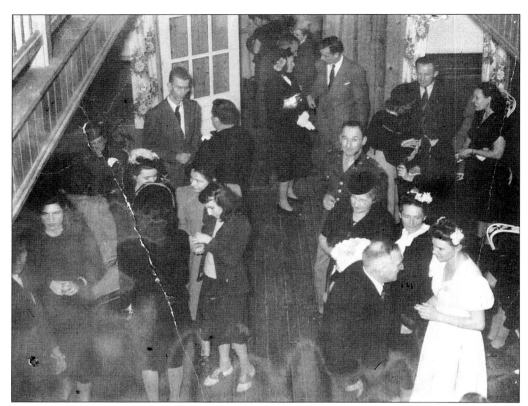

The Lybrand's Ocean Villa at Edisto Beach was often the scene of a wedding reception. The one shown here took place in 1947 after the wedding of Mary Francis Wilkinson and Allen Brockman. Among the guests are Virginia Pope, Mr. and Mrs. Lybrand, Bill Battle, Mr. and Mrs. Parker Connor, Major Parker Connor Jr., Marion Connor, Faith Murray, Jean Smith, Julia Seabrook, and George Cornish Jr.

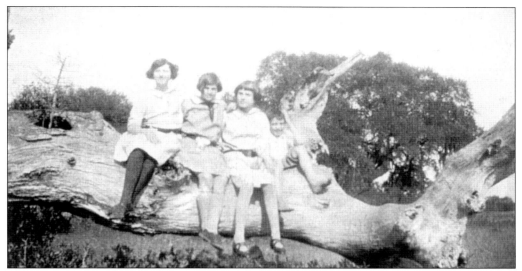

Three teenagers and a little boy enjoy a lovely day and each other's company while sitting on a live oak tree limb that extends out over the marsh. Pictured left to right are as follows: Lilla Jean Murray, Mary Johnstone, Gertrude Bailey, and her brother Billy. The live oak was so-called by early settlers because the tree does not lose its leaves in the winter.

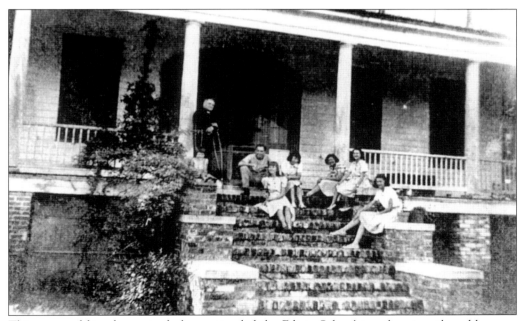

This group of friends, most of whom attended the Edisto School together, is gathered here on the steps of Oak Island with the school principal and his young daughter. They are as follows: Bob Nickles, Sally Crawford, Boots Murray, Dot Crawford, Esther Connor, and Faith Crawford.

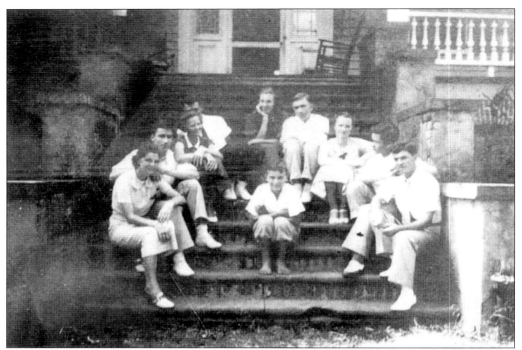

Jack Mikell was the host of this 1937 house party at Peter's Point Plantation. Around the circle from left to right are as follows: Mary Johnstone, Billy Pope, Betty Smith, Jenks Pope, Jean Wilkinson, Bobby Graham, Evelyn Martin, Townsend Pope, Jack Mikell, and (in the center) Jack's younger brother, Julian.

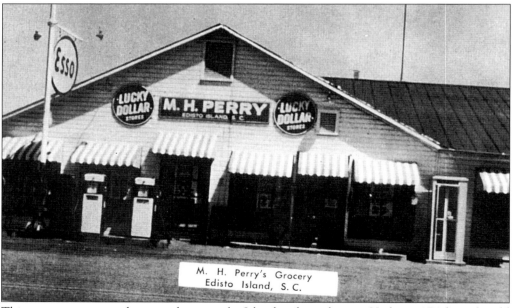

M. H. Perry's Grocery
Edisto Island, S. C.

This grocery store was the second one on the Island and stood across Highway 174 from the old entrance to Middletons Plantation. It has been bought and sold several times, its name changing with each new owner. It is still doing business as usual.

The dock at West Bank is the starting point, or perhaps the end, of a boat trip on West Bank Creek. The ladies' costumes help date the image as early twentieth century.

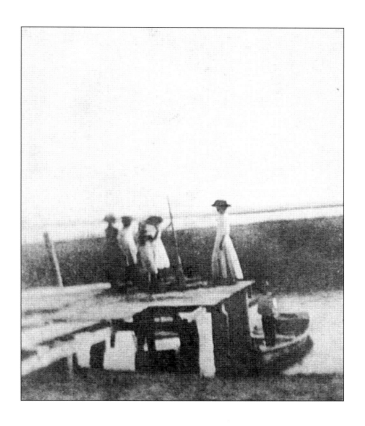

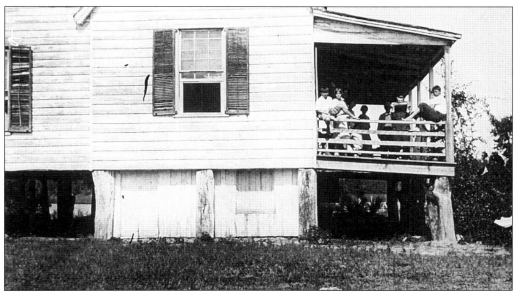

This is another view of the Woodruff cottage on Sunnyside Plantation with members of the extended Townsend Mikell family relaxing on the porch.

Dan and Jenks Pope stand behind their kneeling sisters, Amarinthia Murray, Jennie Allen, and Pollie Murray. The girls, known to be "cut-ups," were all very tall women. This might well be the reason they got on their knees for this photograph taken at Cypress Trees. Their brothers were both slender and not very tall.

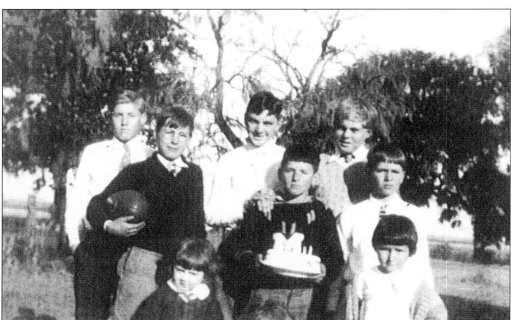

Before the popular use of flash attachments for cameras, photographs had to be made in daylight. This explains why the host at this birthday party is holding his cake in the front yard.

Five

The Land

Since the earliest settlers, Edisto Island has been an agricultural community. Rice was one of the earliest crops to be attempted by the planters, although they soon discovered that the high degree of salinity in the tidal creeks of the Island made the cultivation of rice impractical.

For a time, indigo was a successful and profitable crop due to the demand for the blue dye in England, as it was used, primarily, for the dyeing of work clothes. When the Revolutionary War dried up the market for indigo, and the subsidy of one dollar a pound for the dye vanished, the planters turned to cotton, a crop that proved successful beyond any of their fondest hopes.

Edisto Island long-staple cotton thrived in the Island's soil and climate, and the planters prospered greatly. They built mansions furnished according to the tastes of their forebears, and sent their sons to Harvard or Yale or to study in England and Europe.

The idyllic life of the cotton planters came to an almost abrupt halt just one year after the Civil War began when the evacuation of the Sea Islands was ordered. Much has been written about the devastation that greeted the Island inhabitants after 1865. Their first concern was to find shelter if their homes had been destroyed, or to make livable the homes that were not destroyed. At first, they solely planted food crops for their own use. As time went by, the planters began raising cotton again on a greatly reduced scale. The invention of the cotton gin replaced the time-consuming process of picking the seeds out of the fiber by hand and was a boon to the cotton farmer.

The decrease in the cultivation of cotton began with the arrival of the boll weevil around 1920. A descendant of the Golden Age planters remembers the cultivation of cotton in her childhood during the 1930s. Mr. Oliver Seabrook, who lived at Old House at that time, was the owner of a cotton gin used by neighboring farmers.

After the boll weevil won out over the cotton farmers, truck crops such as cabbage and potatoes became the money crop on the Island, thanks to sophisticated farm machinery. Today the land is predominantly planted with tomatoes and cucumbers.

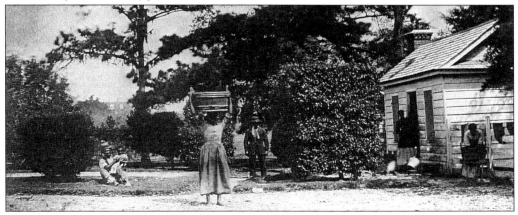

Here is a scene, photographed by H.P. Moore, of Cassina Point Plantation during the Civil War.

Truck farming gradually replaced cotton culture during the late 1930s and early 1940s, and cabbage and potatoes thrived. Farmers shipped their produce almost entirely by boat. This scenic image shows the loading dock at Cypress Trees.

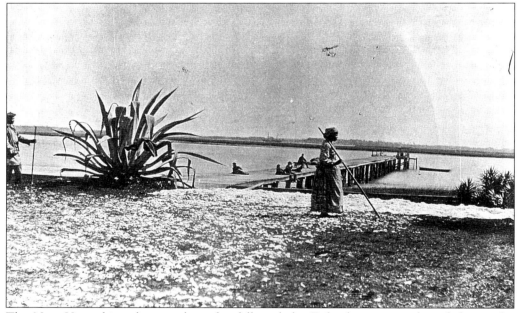

The New Hampshire photographer who followed the Federal troops southward during the Civil War took this high tide photo on the east side of Oak Island house. The cotton loading dock extended out over the marsh to West Bank Creek and, in the distance on the North Edisto River, a Federal gunboat is visible. On the dock are Federal soldiers and in the foreground, two freedmen.

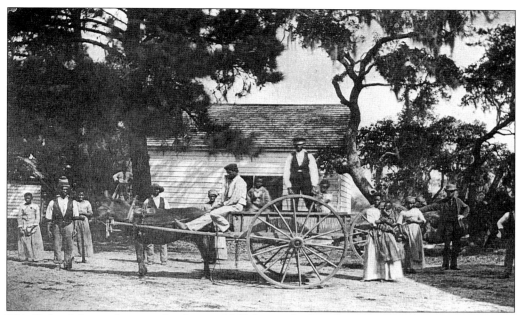

This Federal Army photograph taken in 1862 during the War between the States shows African Americans pausing to have their photographs taken at the Hopkinson Plantation.

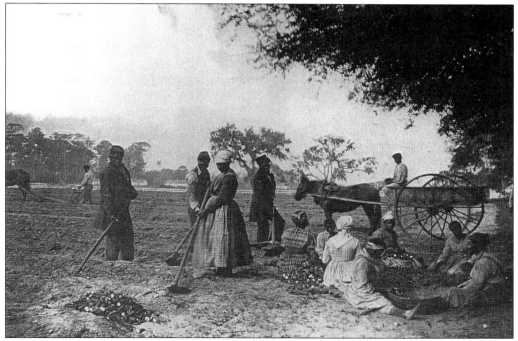

Sweet potatoes were an important part of the plantation workers' diet. Here, freedmen are using hoes to pull them out of the ground at the Hopkinson's Cassina Point Plantation. The men are dressed in Federal uniforms, which were no doubt shared with them by the occupying soldiers. Note: This photograph, taken by the resident Federal army photographer, has been published many times with the location incorrectly identified.

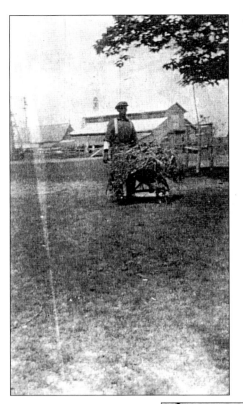

This photo, taken at Bleak Hall in May of 1915, shows Jim Flood working on the grounds of the plantation. Bleak Hall was renowned for its lovely gardens laid out by an Oriental landscape designer brought to Edisto by the Townsends from Washington, D.C. An unusual feature of the design was the incorporation of citrus trees, which are not normally grown so far north.

This scene shows the "street" at Botany Bay Plantation. The number of houses on the street gives one an idea of how many workers were needed to sustain a large cotton plantation. The Townsends were well known both here and abroad for the high quality of their Sea Island cotton.

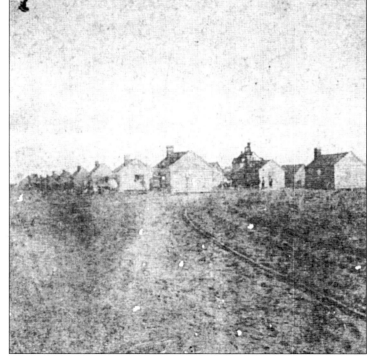

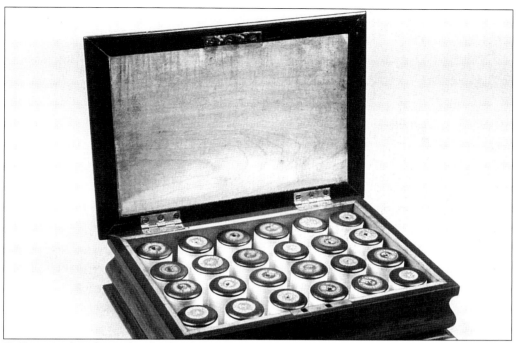

William Seabrook Jr. of Oak Island was presented with this rosewood box of thread in London in 1851. A brass plaque on the lid of the box is inscribed as follows: "Presented by Messrs. Jonas Brooks Brothers, Sewing Thread Manufacturers, to W. Seabrook, Esq. as a specimen of thread produced from his Cotton which took the Prize at the Great Exposition in London in 1851."

The bronze medal shown here in a slightly enlarged image was presented along with the box of thread. The inscription engraved around the edge reads as follows: "Prize Medal of the Exhibition—W. Seabrook, Class II." Likenesses of Queen Victoria and Prince Albert are visible on the face of the medal.

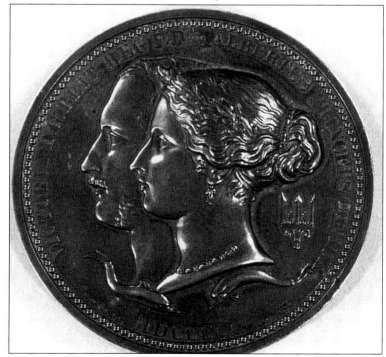

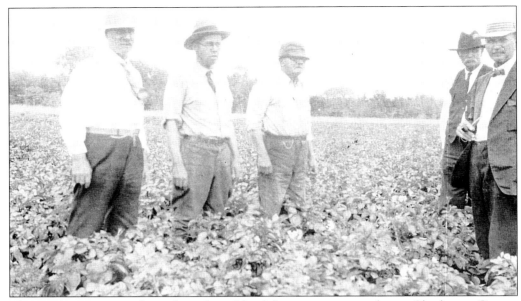

This 1929 image was taken when three Island farmers were attending a Charleston County agricultural conference. Second and third from the left are George Seabrook and G.W. Seabrook, and far right is J.G. Murray III.

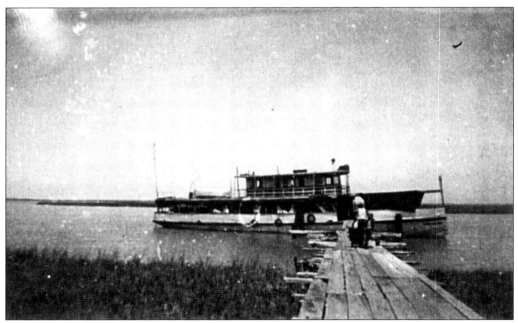

During the 1920s and 1930s, truck crops were shipped off-island by boat. The dock here, pictured at West Bank creek, was one of several used on the North Edisto River side of the Island.

This photo of Old House Plantation cotton fields with outbuilding in the distance gives us a glimpse of how Edisto looked in the cotton-growing days. One old-timer recalls standing on the porch of a house 10 miles from the Atlantic Ocean and seeing "nothing but white fields all the way to the sea."

Ella LaRoche, standing in a cotton field at Cassina Point, demonstrates the height to which Sea Island cotton grew. Because of boll weevil infestations, for which the planters had no effective means of eradication, the growing of the Island's Golden Age crop ground to a halt.

Since life could not exist on Edisto without an adequate water supply, one of the most important mechanisms at both a farm and a house was the well. This image shows the water tank to which water was pumped from a well in order to boost pressure in the house at Cypress Trees Plantation.

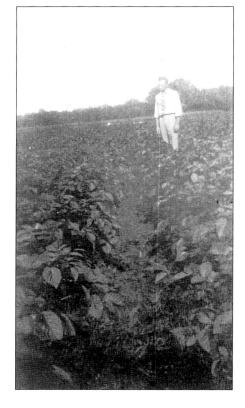

With truck farming as the only means of producing income, it became vital for the Islanders to develop crops that would bring in sufficient money to allow them to keep their farms. One of the organizations that nurtured their ambitions was the Agricultural Society of South Carolina, to which many of them belonged. The society was formed in August of 1785, and the regular meetings afforded an opportunity to exchange knowledge the farmers had gained with particular crops. This scene shows J.G. Murray III checking a vast acreage of Irish potatoes, an important money crop for many Islanders.

Peter Seabrook stands in front of outbuildings at Middletons Plantation, where he worked during the 1930s and 1940s.

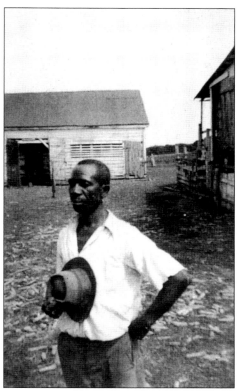

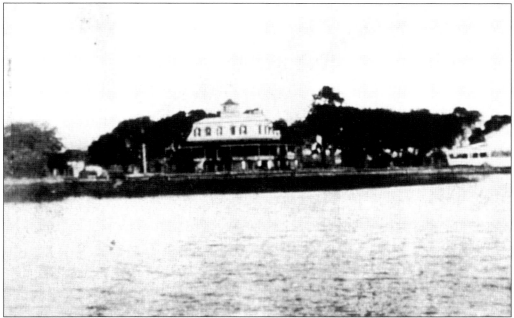

This is Sunnyside Plantation House, built about 1880 by Townsend Mikell, as seen from across Store Creek. The house is different from most Island houses, as it does not follow the usual Edisto plantation house design. An interesting feature is the mansard roof.

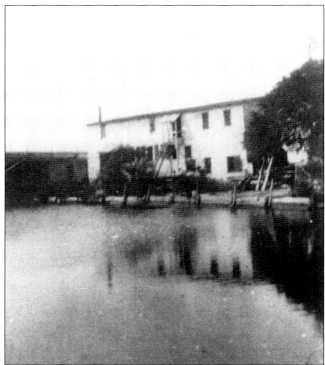

This photo shows the commercial gin house at Sunnyside Plantation. The gin house was used to "gin out" Sea Island cotton, not only that which was grown at Sunnyside but also cotton grown at other Island locations. The tabby foundations of this structure may still be seen.

Townsend Mikell supervises the workers repairing a gate on the Sunnyside property. Islanders had to be self-sufficient in earlier times, doing all of the repairs to their equipment "on the spot."

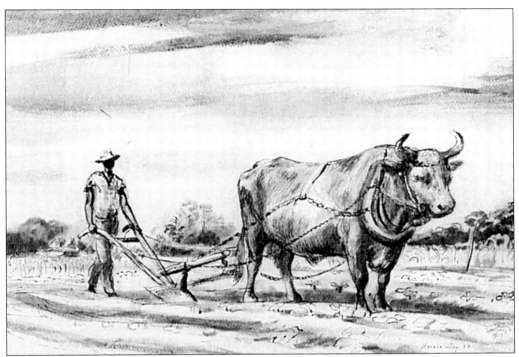

The original of this postal is in the Edisto Island Museum. It shows Edward Simmons using an old-fashioned plow to till his small acreage.

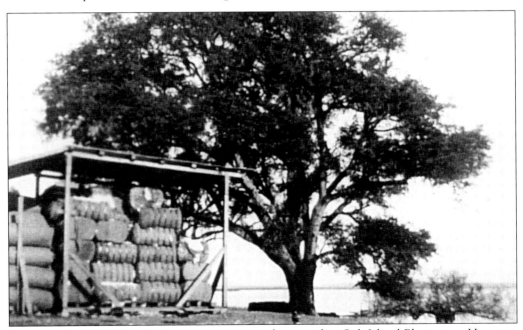

It was in the 1920s that the last cotton crop was harvested at Oak Island Plantation. Here one can see the bales from one of the last crops stacked under a shed by West Bank Creek, ready for shipment to Charleston.

There are many examples of the slow pace of life on Edisto. This photograph, taken at Sunnyside Plantation, shows a farmhand riding a two-wheeled farm cart loaded precariously. Perhaps this is why he seems to be moving so slowly.

Edward Simmons appears with Cow in front of the Murray house, "Jack Daw," on Frampton's Inlet. Edward put a large nail into a tree to tie Cow up while he was visiting at Jack Daw. The nail can still be seen. Sadly, Edward was persuaded to trade his beloved Cow for a horse that died soon after the trade.

Six
Roadways and Waterways

In the beginning, Man had legs. Primitive boats, four-legged animals, wheels, and wings followed in rapid succession as the twentieth century went sweeping by. Man became fascinated with and demanded speed, speed, speed. Not so on Edisto, where the pace of life took a more leisurely course.

Even with the advent of automobiles on Edisto, the pace hardly changed. In order to not upset horses drawing carts and carriages, the automobile owners would courteously pull to the side and turn their engines off until the travelers passed. There was some consternation when one man in his Model T traveled some 10 miles in one hour. Observers shook their heads and muttered, "He is going to kill his whole family!" Other family members worried about their elderly kin in automobiles, fearing that the aged, with failing eyesight, would not see that the swing bridge to take them across the river was not hard up against the land and the drivers would go straight into the water.

Pictured here is Willie Portwick riding his "vehicle" at Brooklands Plantation.

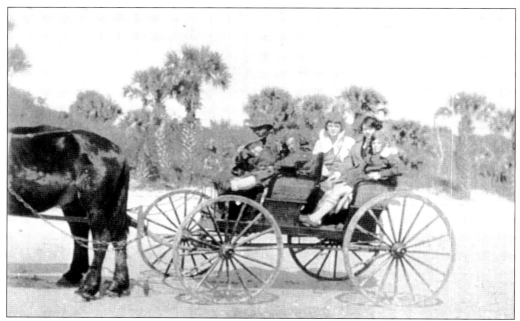

Riding around on Botany Bay Beach with coachman Jerry Miller, Francis Johnstone, Carline Tiderman, Evelyn Townsend, and Mary Johnstone pause long enough to have a picture taken of them in the Bleak Hall carriage.

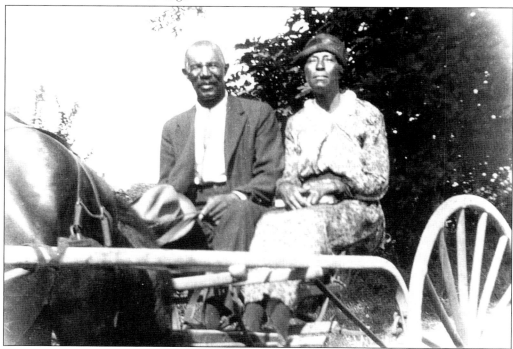

Henry and Rosa Swinton Hutchinson set out in their shay, or gig. The one-horse shay was a popular means of transportation in the country. It first appeared in Paris in the seventeenth century, and made its way to America as primitive roads were developed.

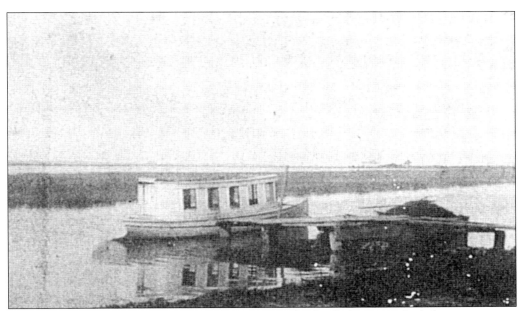

The *Pelican*, owned by Mitchie Seabrook, waits at Oak Island Plantation dock for an excursion on the North Edisto River.

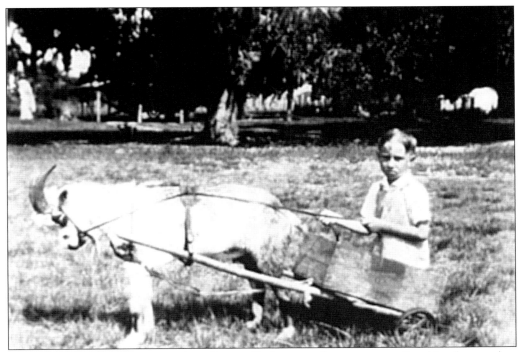

In his version of the one-goat shay, Legare Bailey was all set to go at Brooklands on a hot July day in 1931. Edisto children had to entertain themselves with whatever was at hand, and if the one-goat shay was slow and awkward, it nevertheless gave endless hours of amusement to its passengers.

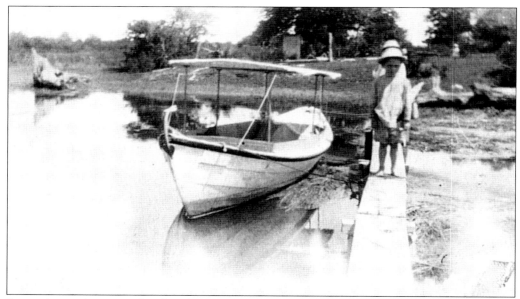

Boats, boats, boats, and a barefoot boy are seen here at Cypress Trees. J.G. Murray III treads fearlessly along the narrow walkway on a lazy summer day to fish or crab, or perhaps, just to dream.

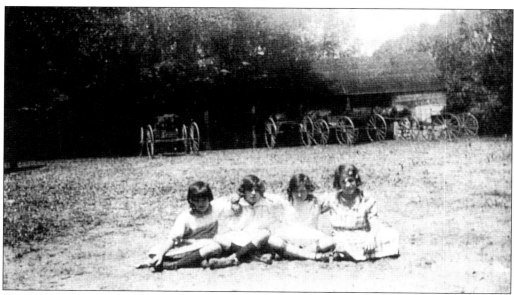

The girls line up for a photograph in about 1920 with the gigs, shays, and buckboards that brought them to school "garaged" in the background. This was the old Seaside School on the grounds of Trinity Episcopal Church.

Chalmers and Caroline Murray proudly ride in a gig in about 1903. They appear too young to be given the responsibility of being drivers, but perhaps they matured early as the outdoor life on Edisto allowed them to freely roam the island with the guarantee that kin would always be near.

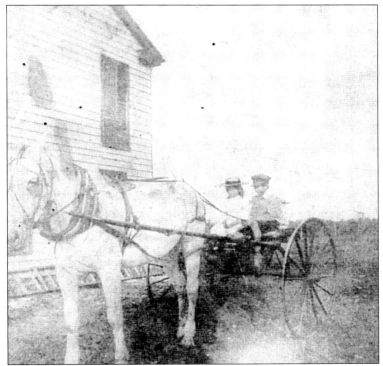

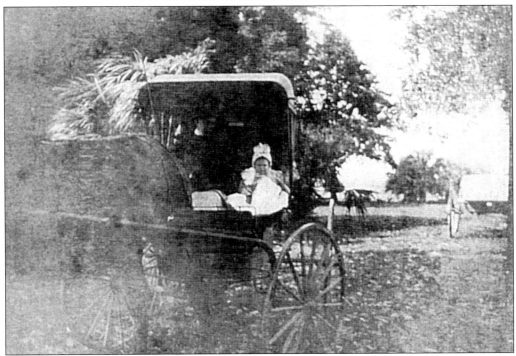

A hooded carriage with a small, beruffled passenger was an irresistible opportunity for a photograph at Middletons Plantation.

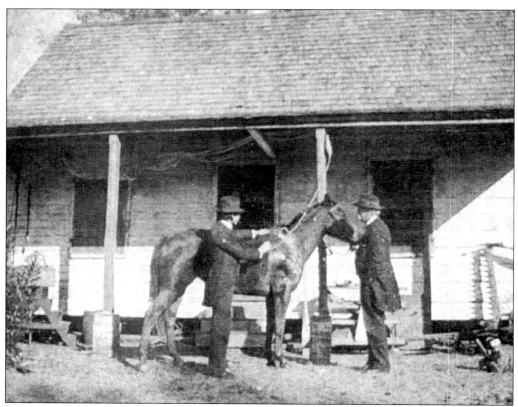

Dr. J.M. Pope, physician, on the left, looks over a horse with his father, Dr. D.T. Pope, at Governor's Bluff Plantation.

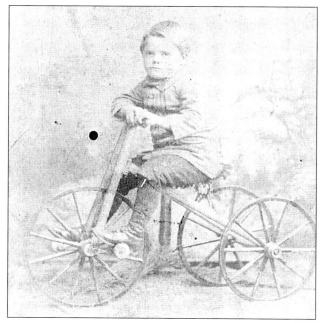

This solemn young fellow views his world from a perch astride his trusty velocipede. The unidentified Islander probably posed for the camera sometime during the late 1800s. His knickers and calf-length boots seem well suited to cycling.

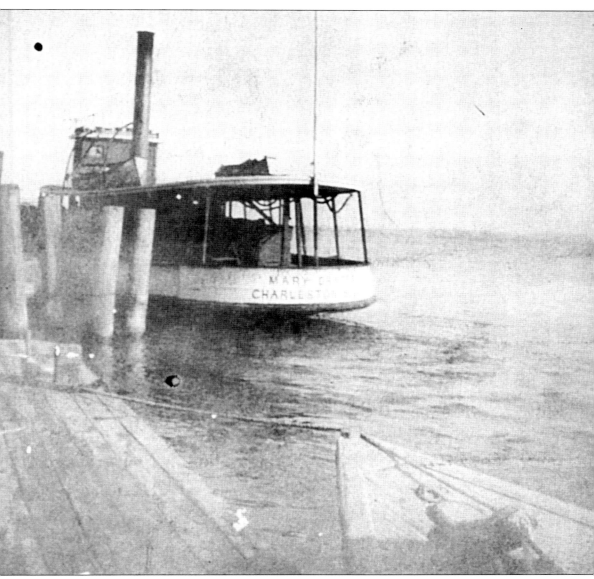

The *Mary Draper*, operated by the Stevens Line of Yonge's Island, carried the mail between Edisto and Charleston. After she retired from this service, she carried Edistonians annually to the Rockville Races.

Thousands upon thousands of fishermen have plumbed the depths of Frampton's Inlet. The inlet is one of the most beautiful of the many waterways that surround Edisto, making it a popular place, even for dolphins that come in to fish and play.

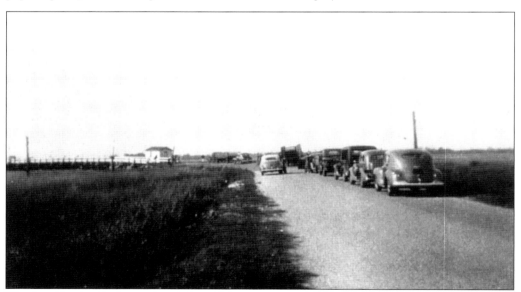

The first Dawho Bridge replaced the old ferry crossing the Dawho River. The ferry, authorized by the South Carolina Legislature in 1825, charged $1.50 for a carriage of four wheels, 6.25¢ for a mule, horse, or ass, and the same for a foot passenger. A hog, sheep, or goat could cross for a mere 3¢.

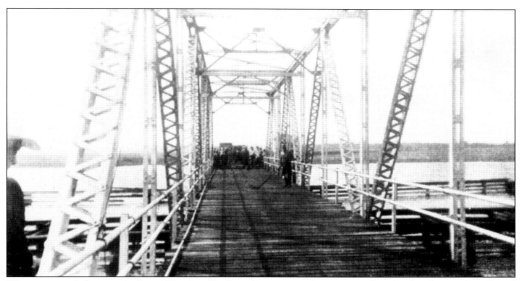

This view of the single-lane Dawho Bridge shows people waiting for the bridge to be closed before crossing. Since the bridge could not be approached unless the tide had gone down, it created an opportunity to visit with neighbors and could have been the origin of "Edislow" time.

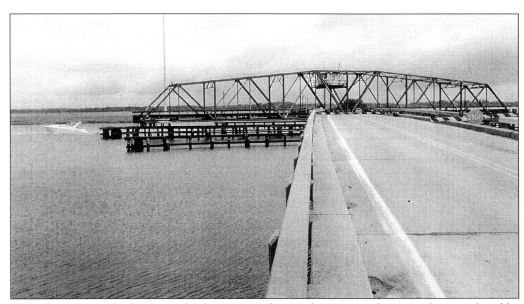

This photo shows the last swing bridge to cross the Dawho River. It has since been replaced by a fine fixed bridge. The old-timers were not too happy with the idea of the new fixed bridge, but it is probable that each "upgrade" in methods of crossing this body of water must have brought the same sort of regrets.

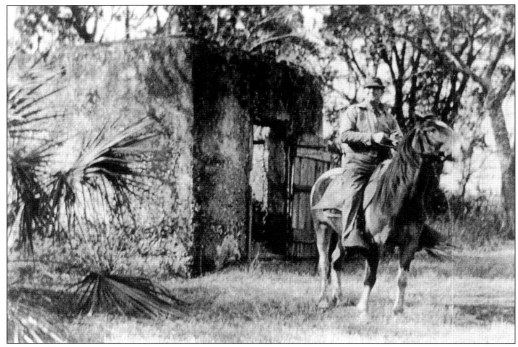

The horse was an important means of transportation. Pictured here is Francis Winthrop Johnstone of Bleak Hall on his horse in front of the tabby smokehouse at Bleak Hall Plantation.

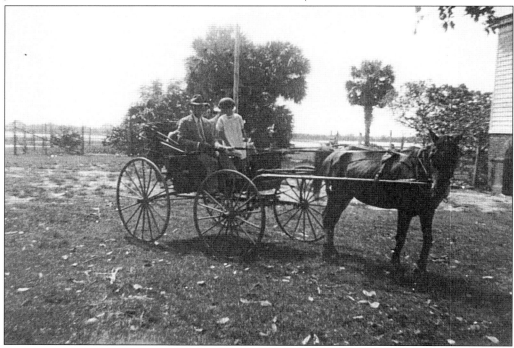

Setting out from Middletons Plantation, Dr. J.M. Pope drives his daughter Caroline and wife (in the rear) to church after the hurricane in August 1940.

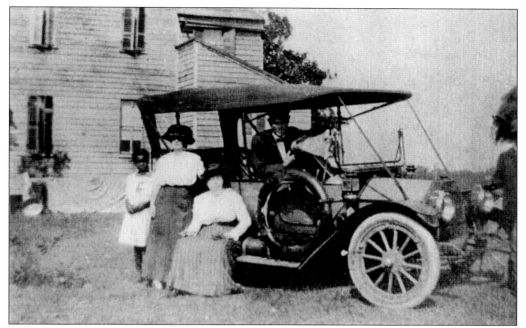

This picture was taken at the Tom Seabrook house, home of Susan and Arthur Whaley. The automobile probably belonged to the Whaley family.

Another photo op! Sarah and Ritchie Belser sit on the bumper of a 1920s Nash automobile.

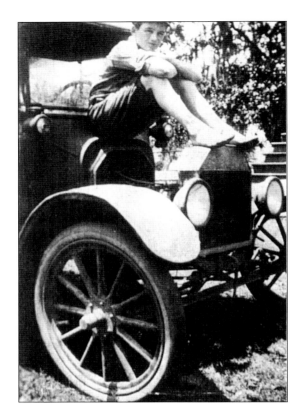

Joseph LaRoche must have dreamed of driving the Ford as he sat proudly on what is left of its hood. Like all of the Edisto boys, barefoot was the way to go.

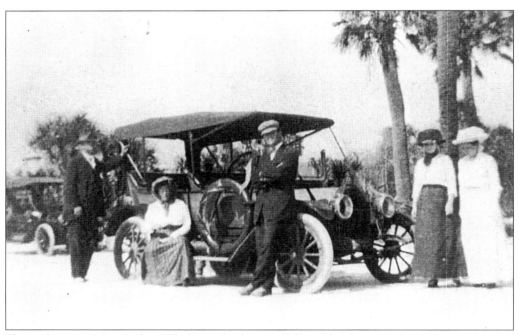

Shown here are Mrs. Arthur Whaley and others on Edisto Island.

Seven
Those Who Served

The young men of Edisto have always been responsive to the call for volunteers in our country's service. The Edisto Volunteer Company was formed in 1776, and its roster and "Agreement to Serve" was signed by 46 Islanders. This prized document has been well preserved and stands as a tribute to those Edisto men who served in our country's fight for independence.

The response by volunteers to the call to arms after Fort Sumter was spontaneous and wholehearted, and the part that Edisto men played in the second fight for freedom has been well documented. They went off to war totally dedicated and full of confidence, and came home to an Island in chaos. One 16-year-old Edistonian, Alonzo Seabrook Bailey, was swept up in the patriotism of his day. He joined the Confederate Army and fought with Anderson's Brigade to prevent Sherman's troops from crossing the South Edisto River.

The First World War found Edistonians in the uniform of their country once more, and the 1941 call to arms brought out a group of Islanders equally dedicated to the cause. They left, they served, and two never returned. One died soon after his return.

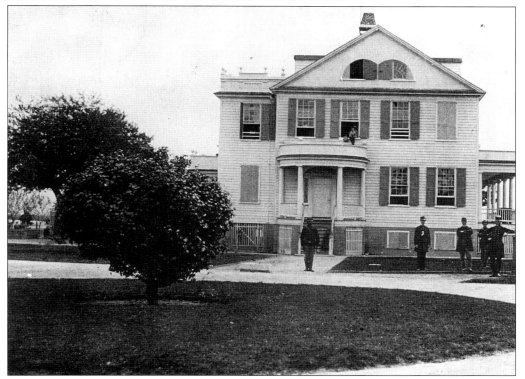

In 1862, Federal troops occupied Oak Island Plantation house. This image, with Federal officers posing in the yard, was captured by H.P. Moore, a professional photographer.

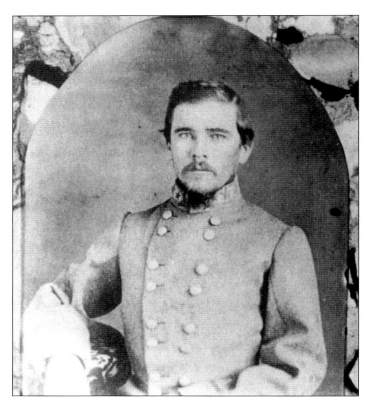

This is a photo of a portrait of General Micah Jenkins of Edisto Island by John R. Schorb. In 1854, and at the age of 19, he graduated from the Citadel as valedictorian. Jenkins and a classmate went on to establish a military preparatory school in Yorkville, South Carolina. He entered service in the Confederate Army on the day after Fort Sumter was fired upon. The troops that he commanded, consisting of the Fifth S.C. Volunteers and the Palmetto Sharpshooters, fought with Lee's Army of Northern Virginia from First Manassas to the end of the war. His troops lost their leader at the Battle of the Wilderness on May 6, 1864. He was a 25-year-old brigadier general.

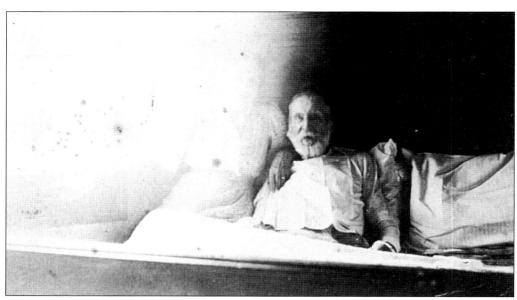

Arthur Westcott was the Island's last living Civil War veteran. In this photo he is pictured with his wife, Addie, at the Veteran's Home in Charleston, where they lived at the time. It has been said that he kept a diary during his service in the war.

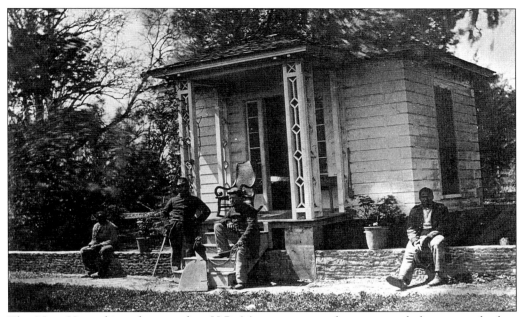

The New Hampshire photographer H.P. Moore seems to have covered the war as both a newspaperman and historian. He recorded on film aspects of life in the South apart from battle. Here, two freedmen and two Union soldiers pose in front of an outbuilding (probably the overseer's office) at Oak Island.

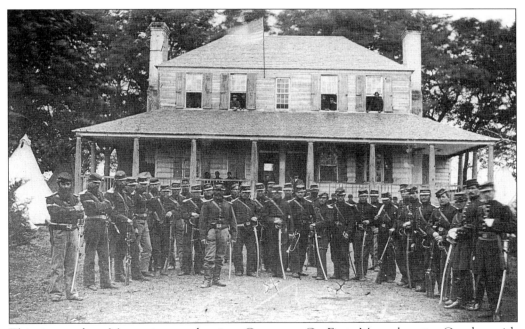

This is another Moore image showing Company G, First Massachusetts Cavalry with headquarters at one of the Hopkinson houses on the Island. Note the U.S. flag flying from the second floor.

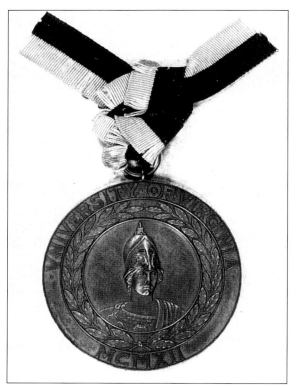

This medal was presented to student Townsend Mikell of Edisto when he left the University of Virginia in 1862 to join the Confederate Army. The reverse side is inscribed with these words: "University of Virginia / Townsend Mikell / 1862–1865 / The gift of Alma Mater / to her son." The medal is a treasured keepsake, framed and hung on a wall at Sunnyside.

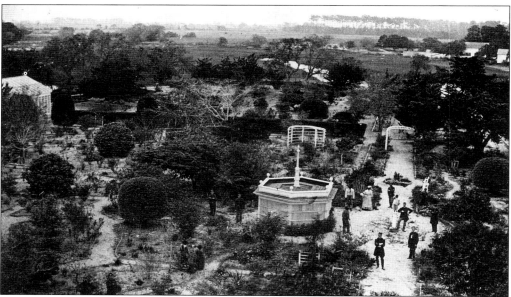

This Moore photo is a view from the second floor of Oak Island looking south toward Cassina Point. In the foreground, where freedmen and Federal soldiers are standing in the garden walks, one can see the aviary which is said to have contained a golden eagle. To the extreme left is a structure which could be an exceptionally tall greenhouse or a free-standing solarium containing exotic tropical plants.

This is a photograph of a painting hanging in the William Seabrook house today. It had hung in the same house prior to the Civil War, but was given to a sea captain and his wife, as they delivered horses by boat to the Federal troops then occupying the Island. According to a letter (dated June 25, 1959) written by the man who returned the portrait to the present owners of the house, "When the Union officer was about to run a sword through the painting, my grandmother said it was too bad to destroy such a painting . . . he took down the entire picture with frame and gave it to her and my grandfather."

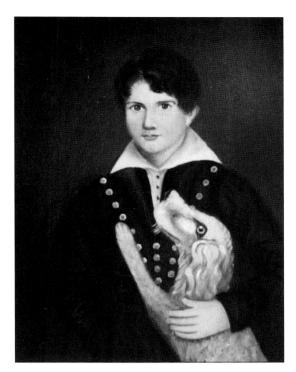

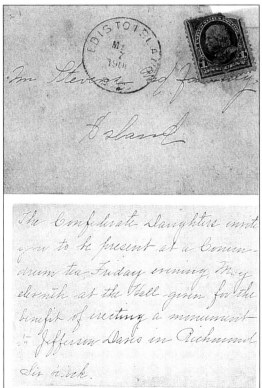

The Confederate Daughters were members of the United Daughters of the Confederacy. The address on this envelope is one more piece of evidence to prove that life was certainly simpler in years gone by.

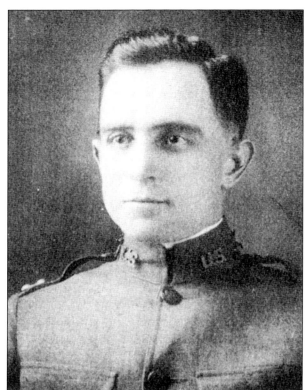

This photo of "Mac" Holmes shows him in his First World War uniform. As the harshness of the conflict took its toll on him, this veteran came to Edisto to recover his health and managed a plantation on Peter's Point Road. Later, he and Mrs. Holmes became the first permanent residents of Edisto Beach.

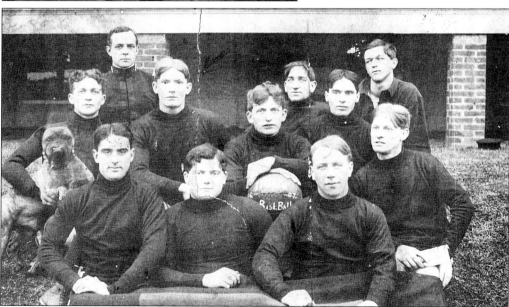

Troops in training on military posts during WW I often formed unit sports teams to compete against other unit teams. An Edisto Islander was on this basketball team. They sit proudly behind their unit ensign. The second soldier from the left on the second row is identified as Francis Wilkinson of Edisto.

This is another image taken at the Island's gathering place—Bailey's Store. Chalmers Murray, a newspaperman and novelist, poses in his WW I uniform. With him, pictured from left, are Frank Wilkinson (who also served in the war), Mrs. Frank Wilkinson, and Parker Connor (the schoolmaster).

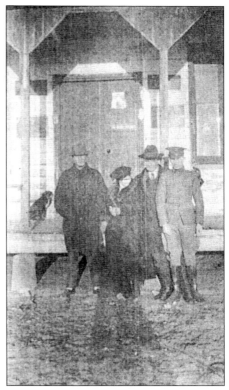

Jane Murray, the daughter of Chalmers Murray, served in WW II as a Navy nurse. She grew up at her ancestral home, Jack Daw Hall at Frampton's Inlet. She and her husband, Dr. Edward McCollum, returned to live in the old home place after they retired.

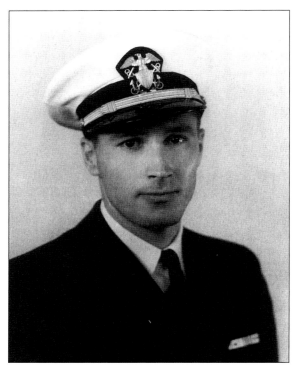

Commander William Nelson Pope entered the U.S. Navy Medical Corps as a lieutenant (JG) in August 1941, serving aboard ships fighting in the Pacific until November 1945. He was reassigned to stateside Naval hospital duty until his discharge from the service in October 1947.

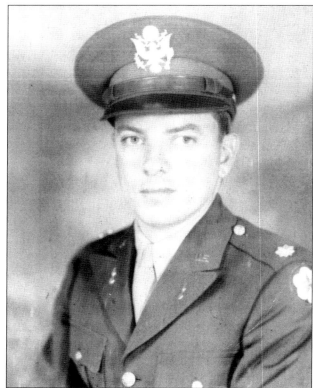

Lt. Col. William Robert Bailey served from 1942 until his discharge in 1946 as a bomb disposal officer in the Ordinance Branch of the Army. He and his wife, Pinckney, live on James Island beside the Stono River.

These two sons of the Island are first cousins: Navy man Arthur Spencer and Army man Gerry Murray. They were probably on home leave because the background looks very much like the Lowcountry.

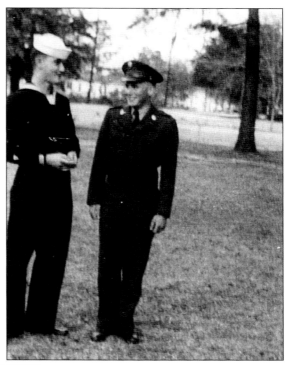

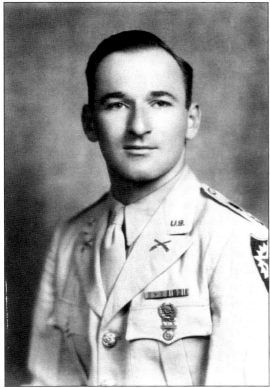

Parker E. Connor Jr., son of the Island schoolmaster, became a career army officer in 1939 and retired in 1976. He spent 33 months of WW II years in the Aleutian Islands and the remaining years during the war with infantry training units in the States. After retiring, he and his wife moved into his ancestral home, Oak Island, on Edisto and restored it. Part of this project was the restoration of the grounds surrounding the house where many varieties of camellias grew, although sadly neglected. This passion created eight-hour workdays and recognition as one of the foremost camellia cultivators in the United States.

Eldon D. Hunter Jr. is one of three Edisto men who lost their lives in WW II. A member of the U.S. Air Corps, E.D. was reported missing in action when his plane left the formation. He was never found. Eldon and his parents moved to the Island in the 1920s.

First Lt. John M. Jenkins, who grew up at Brick House Plantation, served in Europe with the U.S. Army 100th Division during WW II. In action in France in 1944, Lieutenant Jenkins single-handedly destroyed a machine gun nest. Unknown to Jenkins, his battalion commander witnessed this act of bravery and recommended him for the Silver Star Medal. Unfortunately, the records were lost and he was not notified. The record eventually came to light under an extraordinary set of circumstances, and Jenkins was awarded the medal at the Citadel Homecoming in 1980 by his classmate Gen. William C. Westmoreland.

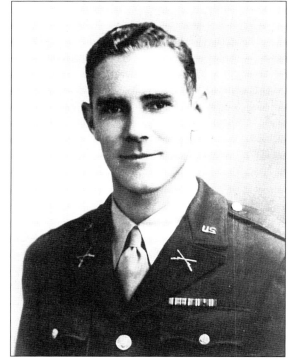

Lt. Daniel Townsend Pope, U.S. Army Air Corps and younger brother of Navy Commander William N. Pope, received his wings in August 1941 at Craig Air Field in Selma, Alabama. He was killed in a bomber training crash at a base in Smyrna, Tennessee.

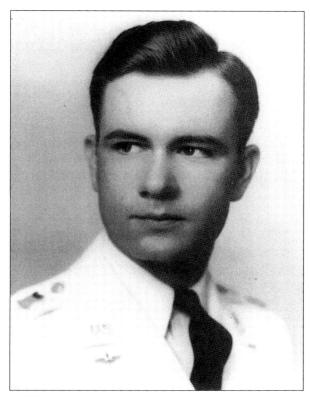

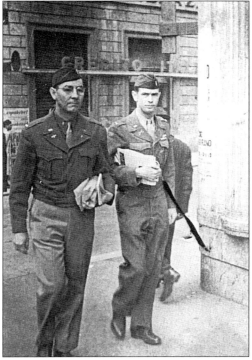

In a snapshot taken by a street photographer in Rome, Italy, Army Lt. Daniel Townsend Pope is visible on the right. He served most of his Army time in the European Theater of Operations, and later married Adelaide Seabrook of Cassina Point. When they both retired, they returned to Edisto and built a house on the Governor's Bluff land where he grew up.

Francis Johnstone Jr., son of Mr. and Mrs. F. Winthrop Johnstone of Bleak Hall, returned from WW II, during which he had been injured but discharged from the hospital. He was at home only a short time when he died suddenly, apparently as a result of the war wounds.

Marion Whaley served in the Army Air Corps during the Second World War. When he retired, he returned to Edisto and opened South Point Services, a convenience store on Edisto Beach. Whaley served as mayor of Edisto Beach and was a familiar figure to vacationers who spent their summers and holidays there.

Eight
Schools and Churches

The late-eighteenth- and early-nineteenth-century settlers of Edisto Island were northern Europeans. The majority of them had excellent educations and expected the same for their children. The sons and daughters began their schooling at home tutored by their mothers or governesses or tutors. Some of the young people were sent to preparatory schools. This type of education prepared the boys for college entrance, but the young ladies were not expected to enter college.

During the years following the Civil War children were taught at home or were sent away to live with relations in communities that had public schools. The first public schools were established on Edisto Island in the nineteenth century.

Most of the early settlers were Presbyterians or Episcopalians. During the years when the two churches were served by supply ministers from nearby islands, the two congregations worshipped together on alternate Sundays.

After the Island's occupation by Federal troops early in the Civil War, freedmen took over the Presbyterian Church for their services. After the war, the church was reclaimed by residents who had returned to their homes. The freedmen subsequently built churches for their congregations.

The Seaside School, which stood on the grounds of Trinity Episcopal Church, was used before a larger school was built on the highway, diagonally across from the entrance to Oak Island Road. The Seaside School burned, but the larger school still stands, now used as a community center. The young scholar standing on the porch railing is Chalmers Murray. He grew up to be a prolific writer, his works helping to preserve a great deal of the Island's history.

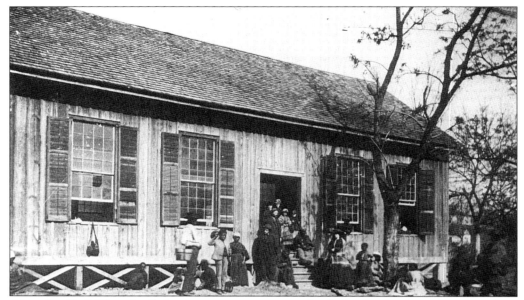

After the Civil War, the Federal government set up schools for the freedmen. Teachers from the North who volunteered to work on Edisto lived and taught under the most trying conditions. The school buildings and houses where they lived and taught were in disrepair, often without heat, cooking facilities, or furniture.

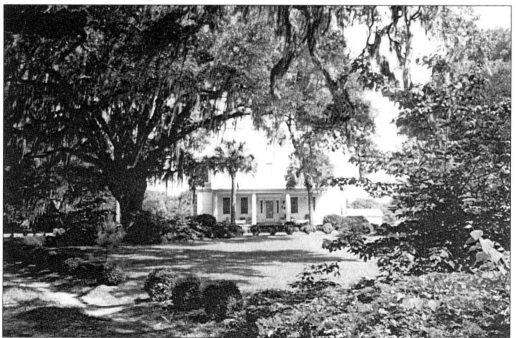

One Freedman School was set up at "Crawfords" plantation house off of what is now Oyster Factory Road. Two missionaries from Massachusetts left their well-to-do families to teach and live on the Island. One, Mary Ann Ames, published a diary of her Edisto Island days. She wrote vividly of the hardships that she and her friend endured.

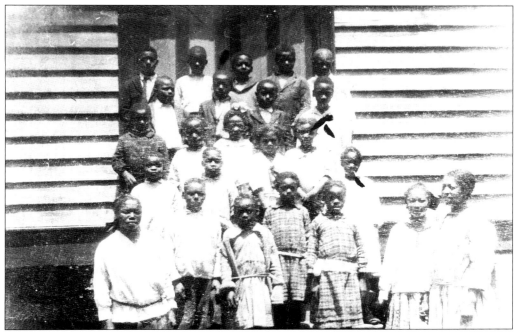

This image shows the student body and the director of the Larimer School, organized and run by the Presbyterian Church, which was then located at the corner of Highway 174 and Steamboat Landing Road. The school was on the church grounds. Lula Hutchinson Whaley is the teacher in the group. The school is no longer standing.

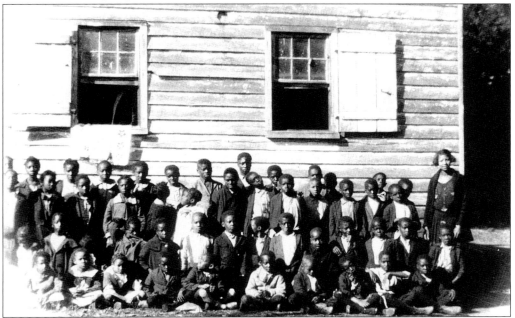

Mabel Hutchinson taught at the Seaside School, which was in use from 1877 until 1940. Before Highway 174 was re-routed and paved in 1940, the school fronted on Edingsville Beach Road. The building still stands, but is unused.

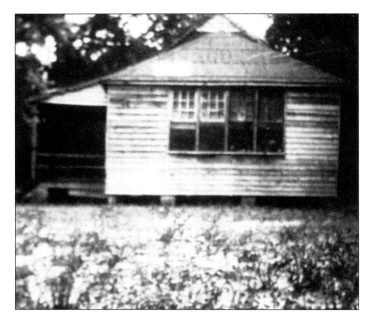

This is another view of the Seaside School as it looked in 1918. It housed both the elementary and high school combined. The two white schools (Seaside and the Borough School) were consolidated when the new school was built in 1925.

A group of Seaside School students pose here in the schoolyard. In the background one can see the carriage house where buggies along with their horses were "parked" during the school day.

This scene shows a group of students in the schoolyard with Dr. Banov, a Charleston pediatrician who was also the county health inspector. The schoolgirls are, from left to right, as follows: Pinckney Bailey, Rena Hills, Edith LaRoche, Mary Murray, Mary Johnstone, Sarah Johnstone, and Zilla Hills.

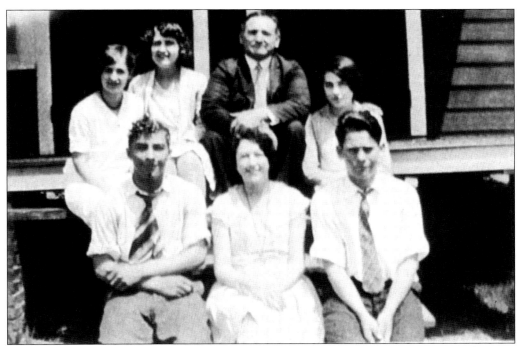

The school principal (with English teacher Miss Campbell), Parker E. Connor, sits on the steps of the school with some of his high schoolers. The students are as follows: Deligall Jenkins, Lilla Jean Mitchell, Percy Hills, Charlotte Pope, and Gertrude Bailey.

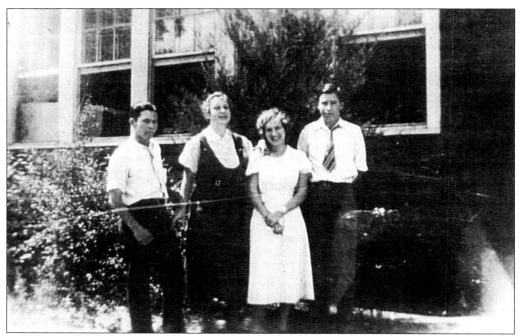

Pictured in the schoolyard in the early 1930s are, from left to right, as follows: an unidentified person, Pinckney Bailey, Rena Hills, and Billy Pope. These four students made up a complete class, graduating together later.

This group is also one class—probably ninth or tenth graders who went on to graduate together. Small classes ensured a great deal of individual attention for each student, which must have accounted for the high percentage of college graduates among those who attended the school.

J.G. Murray III played the part of Tom Thumb in a minstrel presented by the school each year. In this photo, he poses in the costume he wore in one of the productions.

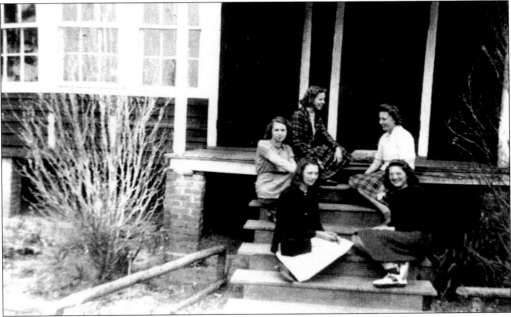

High school teacher Florence Parks sits with some of her students in the early 1940s. The students pictured are as follows: (front row) Inez McTeer and Neenie Cannon; (back row) Miss Parks, Jennie Holmes, and Marguerite Seabrook. Florence and her husband, Laurence Johnston, retired to Edisto Beach, where she became a tireless worker in the organized efforts to protect the loggerhead turtles.

A MYSTERY PLAY IN THREE ACTS

- BY -

JEAN LEE LATHAM

✧✧✧✧✧✧✧✧✧✧

THE ARMS OF THE LAW

✧✧✧✧✧✧✧✧✧✧

PRESENTED BY

THE EDISTO ISLAND PARENT TEACHERS

BENEFIT OF

THE SCHOOL LUNCHROOM

EDISTO ISLAND, S. C.

FRIDAY, APRIL 11, 1947 -- 8:00 P.M

The Edisto Island School presented a fund-raiser directed by the principal, Marian Murray, with a cast made up of parents, teachers, and other residents who lent their talents to the project.

PROGRAM

CHARACTERS

Directed by MARIAN MURRAY

Countess Bartova	Clytie Sayer
Madame Caritza	Jinny Pope
Olga	Clara Puckette
Mary Maguire	Marian Murray
Madame Palinsky	Erline S. Jenkins
Therese	Mattie Tawes
Katya Brunin	Azulah Harrison
Emily Andrews	Adelaide Pope
Miss Frazier	Jewell Bradham
Miss Larkin	Catherine McTeer
Voice	J. M. Pope, Jr.
Scenery and Publication	Eleanor Andrews
Lighting and Sound Effects	Elliott Puckette
Scenery and Publication	Eleanor Andrews

PLACE—The living room in the home of the Countess Bartova

TIME—The present—a spring evening

✧✧✧✧✧✧✧✧✧✧

SYNOPSIS

ACT ONE—Living room in the home of Countess Bartova

ACT TWO—The same—shortly after act one

ACT THREE—The same—shortly after act two

108

Jenks Mikell Pope, one of the many Edisto Consolidated School graduates, went on to graduate from Clemson. He was one of the very few college graduates who returned to the Island and farmed at Middletons Plantation.

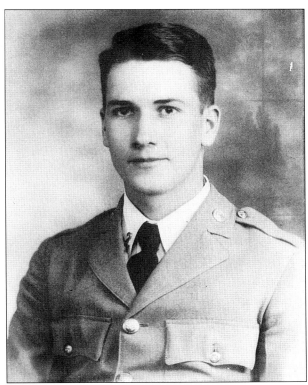

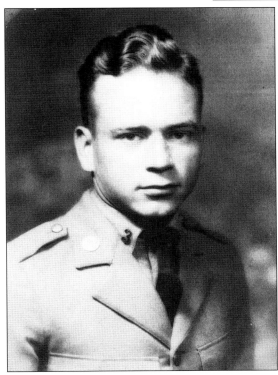

J.G. Murray III attended Bailey Military Academy, later graduated from Clemson, and returned to Edisto to farm at Cypress Trees Plantation.

Ellen Holmes was one of four sisters who attended the Edisto school. She was singled out for this snapshot while fellow students hang back on the steps of their school. The Holmes family lived in the only permanent residence at Edisto Beach at that time.

Starling Mikell, who grew up at Peter's Point Plantation, is another Edistonian who attended Clemson early in the 1900s. He was the son of John Mikell.

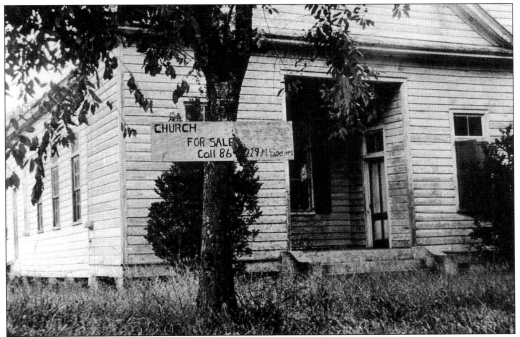

The Edisto Island Presbyterian Church once stood at the corner of Highway 174 and Steamboat Landing Road. It served the Island blacks for many years, until it was sold (note the sign in the photo) and a new brick church was built farther down and off the highway. After the old church was sold, it was dismantled board by board and used for construction elsewhere.

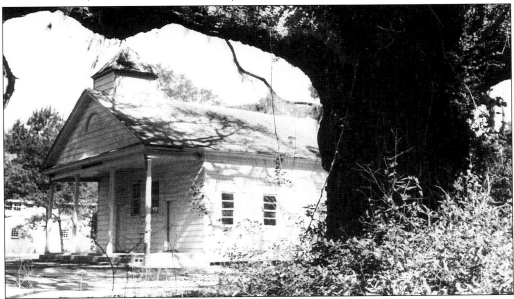

The Zion A.M.E. Church is located on Highway 174 not far from Trinity Episcopal Church. It is believed (but there is no confirmation to date) that this building was originally on Edingsville Beach and, after hurricanes and the 1886 earthquake, was floated down Store Creek to its present site.

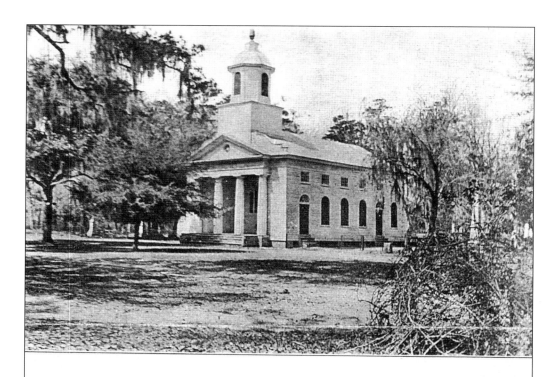

THE EDISTO ISLAND PRESBYTERIAN CHURCH

EARNESTLY REQUESTS YOU TO BE PRESENT

IN PERSON

WHERE SHE WAS FIRST FOUNDED

ON EDISTO ISLAND, SOUTH CAROLINA

IN THE CELEBRATION OF HER

TWO HUNDRED AND FIRST BIRTH YEAR

APRIL 28TH, 29TH AND 30TH, 1911

"THE LORD HATH DONE GREAT THINGS FOR US;
WHEREOF WE ARE GLAD."

The Presbyterian Church on Edisto Island was so designated to distinguish it from "the Edisto Island Presbyterian Church" because of mix-ups in the delivery of mail. This is the second sanctuary used by the Presbyterians here, although little is known of the first one, except that services were shared by the Island Baptists. After the Baptists acquired their own church, the Presbyterians retained use of the building. Most historians believe that the church was founded between 1686 and 1710, making it the oldest in continuous existence in South Carolina.

112

Nine
Beach Life

Beaches played a prominent part in the lives of Edistonians, as they lived on the margins of the Atlantic Ocean. The most important beach in the life of nineteenth-century Edistonians was Edingsville, established about 1824, where they summered to escape the "miasma" of the marshes.

Edisto author Chalmers Murray describes the migration every May to the very substantial, two-story houses at the beach as follows: "The plantation houses were denuded of furniture from heavy four-poster beds to kitchen chairs and doll tables." He adds, "Chickens, cats, dogs, hogs, cattle, mules, and horses all went to the beach."

By 1870, more than 60 buildings, including dwellings, one store, two churches, and an improvised school, had been built. Happiness reigned supreme on Edingsville. Older people relaxed, children ran wild, and the young people reveled in the social life of the village.

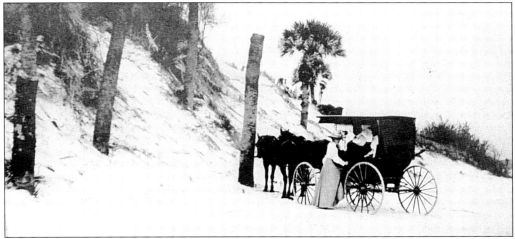

In this image, one can see the high dunes that were once a familiar sight on Edingsville and the horses, carriage, and passengers pausing during their "process" down the beach. In 1874, Edingsville was visited by a hurricane which swept away all of the buildings but three. An earthquake in 1886 and another hurricane in 1893 moved Edingsville into the ocean, and its bones now lie a half mile out to sea.

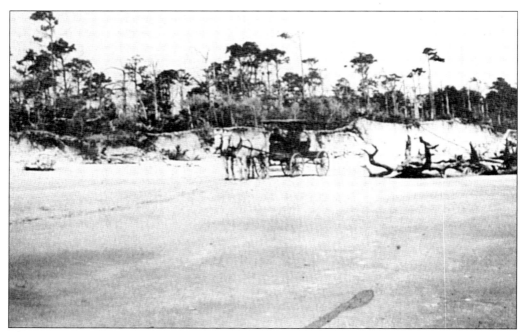

This carriage makes its way along the beach, carrying villagers for social visits with neighbors. The menfolk returned to their plantations on Edisto during the day, but, before the sun set, they would be on their way back to Edingsville to join in the fun and frolic on the beach.

No longer in existence, these beach houses were on Botany Bay Island. There is no sign now that they ever existed. Mary Johnstone Lantz, who grew up at Bleak Hall on Botany Bay, says that the late Ella Seabrook chaperoned beach parties of young people at these cottages, which were built to house Bleak Hall guests.

This is "Miss Ella," the chaperon, at Cowpens. "Miss Ella," as she was fondly called, was a Seabrook, the granddaughter of Carolina Lafayette Seabrook Hopkinson of Cassina Point. Miss Ella grew up at Cassina Point and married William Edings Seabrook in 1916. Cowpens was a tiny "village" of beach houses.

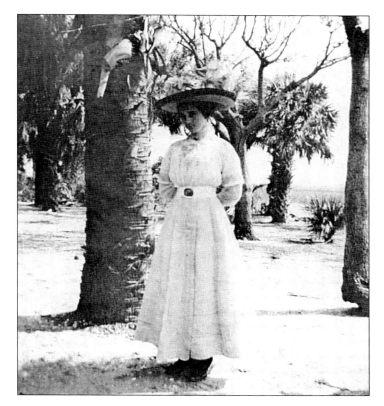

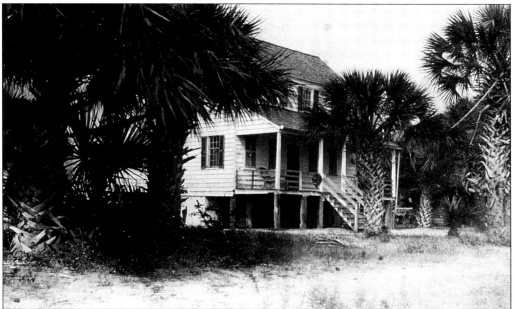

The LaRoche summer cottage in Cowpens witnessed many a beach party in days gone by. It was not too far to walk to the present Edingsville Beach for a romantic stroll along the strand in the moonlight, or to watch for the arrival of loggerhead turtles laying their eggs.

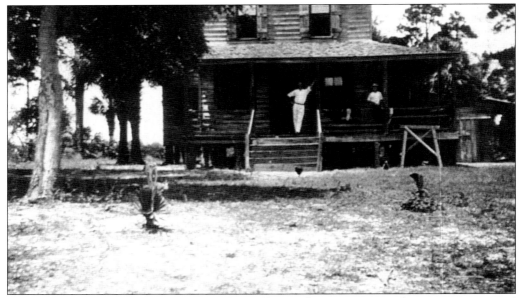

The Whaley House was moved from Edingsville Beach to Cowpens, where it was occupied during the summer months by William James Whaley, his wife, the former Martha Elizabeth Bailey of Rockville, and their family. Like so many others that were at Cowpens, this house is no longer standing.

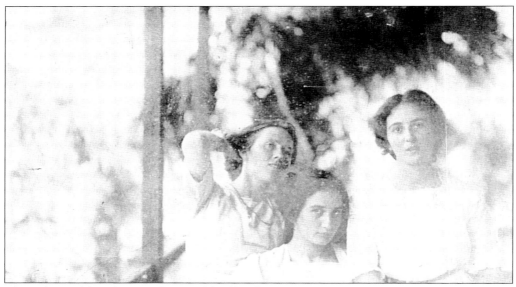

These beautiful girls—Caroline Caldwell, Ella LaRoche, and Julie Mikell—relax on the LaRoche cottage front porch at Cowpens in 1911. The girls no doubt entertained themselves with reading, beach strolls, and gossip, whiling away the lazy summers much as people do now at the beach.

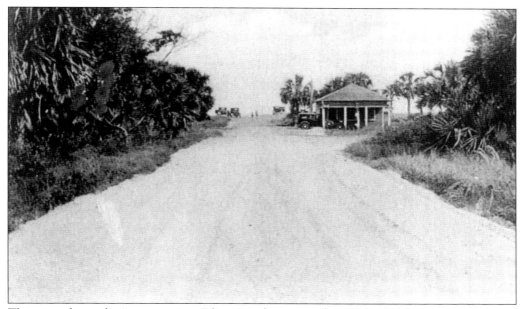

This view shows the "causeway" to Edisto Beach in 1934, long before Edisto Beach developed into a town. The little building in the distance was replaced by the Pavilion, which burned down in 1984 and was then replaced by the present Pavilion. Gone today is the rich, dense growth shown here.

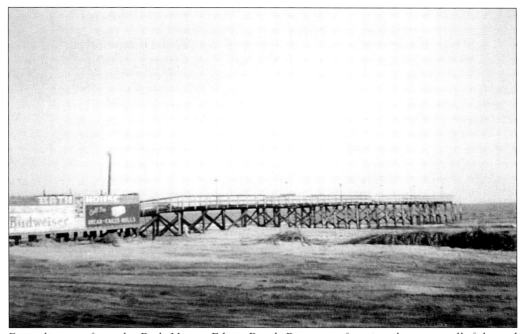

Extending out from the Bath House, Edisto Beach Pier was a favorite place to stroll, fish, and meet the neighbors. However, it could not withstand the heavy pounding of waves and hurricanes, and was long ago claimed by the sea.

Summer days at the beach brought friends and relatives together. Charlie Thomas, Elizabeth Jenkins, Anne Moore, and Bill Wallace stop just long enough to allow the photographer to capture them being blown about by a strong wind.

These 1933 bathing beauties—Mary Boggs, Mary Virginia Allen, and Charlotte Pope—"ham it up" on Edisto Beach. Their happy faces express the sheer joy we all feel at the seashore.

In the summer of 1945, Frank O'Connor and
Carl Culler sit on the steps of the old Pavilion. It
looks as though they are cooking up a little
summer mischief.

The Edisto Beach bowling alley (below) stood on
the corner where a convenience store is now, and
served as the social center of the beach. Old-
timers start to reminisce about their summers at
the bowling alley, and it is not long before they
are wracked with laughter. "Wild boars ran the
Beach in those days," says Rosa Gressette
Bresnahan. "They'd run down to the end of the
Island when the shrimpers came in. The men
would throw crabs to them. The big boars could
catch the crabs, but the little ones would squeal
their heads off when the crabs grabbed their
snouts." She continues, "This was the sort of
entertainment we had in the old days—everybody
knew everybody and it was a laugh a minute."

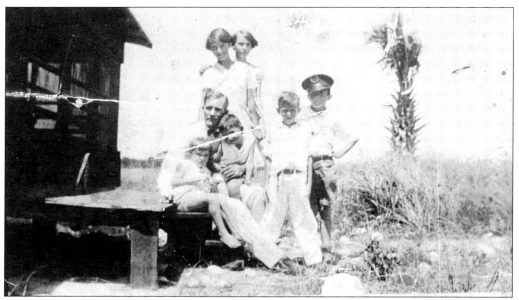

Edisto Island lawman Frank Wilkinson sits on the "porch" of an Edisto Beach cottage in 1933 with his daughter Mary Francis and cousin Jimmy Baynard on his lap. Standing left to right are Mary Baynard, Jean Wilkinson, and Bill and Bobby Baynard—barefoot, as usual.

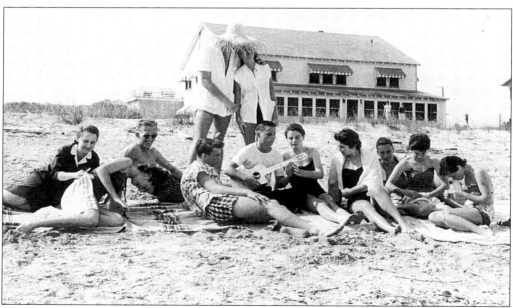

The Ocean Villa, a friendly beach boardinghouse owned by Harvie and Jennie Lybrand, was another important social center on Edisto Beach. People came in the summer from far and near for their little glimpse of "heaven on earth," staying in the villa and enjoying hours of lazing away the warm summer days interrupted only by delicious meals. Many former guests acquired beach houses and continue to come to Edisto, bringing their "grans" and "great grans."

The Ocean Villa's three Lybrand boys, Sammy, Tommy, and David, stand next to the "catch of the day" hanging in front of the boardinghouse. Old photos of fish harvests on Edisto invariably show monstrous fish of a size we no longer catch inshore.

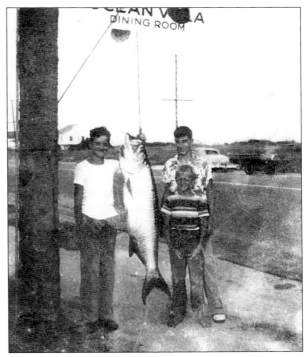

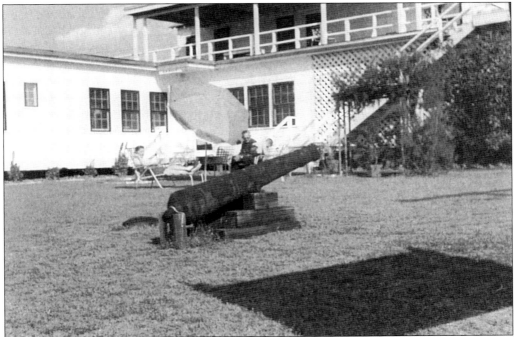

This image shows one of two pre-Revolutionary cannons on the land side of the Ocean Villa, originally found on the southern end of Edisto Island by David and Sam Lybrand in 1959. Already an antique in 1862, the cannon was probably acquired from the British for coastal defense in the War between the States.

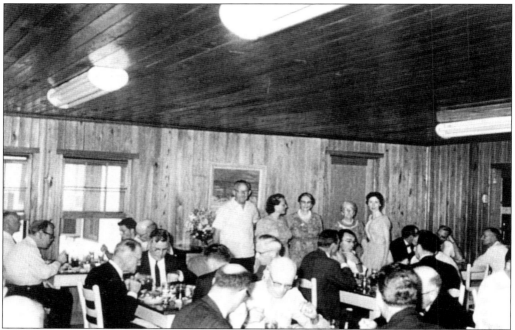

With the gentlemen seated and the ladies and Harvie Lybrand standing, this appears to be a photograph of a meeting of the Edisto Lions Club. The Lions Club was and continues to be a very important part of the life on Edisto. In the summer, the Lions run a bingo parlor at their club hall that raises money for the invaluable work they do, particularly in the field of eyesight.

"Pheu!" Lottie Pope, Ella Seabrook, and Julia Paisley Mikell take a rest from cooking and serving the Lions Club dinner meeting at the monthly get-together at the Ocean Villa.

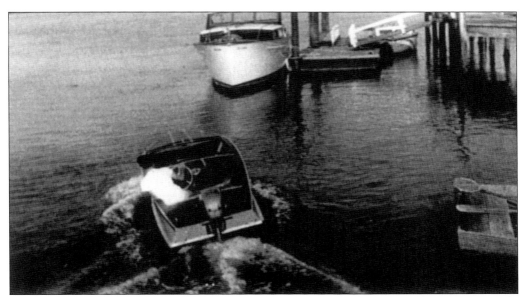

This Edistonian is seen here "scratching off" from Bell Buoy Sea Food Dock into Bay Creek. Boating, fishing, crabbing, and shrimping occupy a lot of both vacationers' and residents' time. One permanent resident recalls working at a frantic pace when he visited on vacation. "Now," he says, "since I moved here I never seem to have the time for these pleasures."

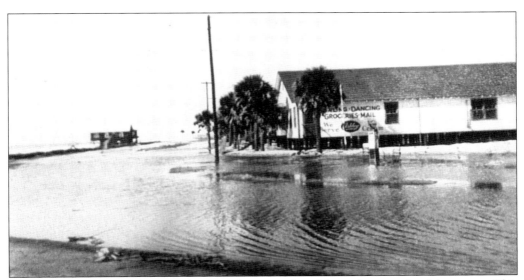

Since Edisto Beach is a barrier island beach, it is vulnerable to the inroads of the ocean. This photograph taken after a hurricane shows the devastation that can be a frequent occurrence when man-made structures are constructed at the water's edge.

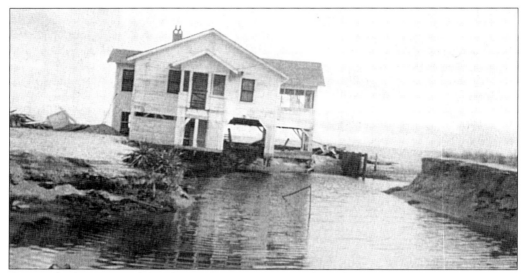

Gracie, the hurricane of October 1959, came roaring ashore, leaving this Palmetto Boulevard house high but not dry.

This is an early-1940s photo of the Edisto Beach State Park, which was established in the late 1930s. Roads, restrooms, and a park bathhouse were constructed by the Civilian Conservation Corps. The park welcomes campers year round and has provided an ideal setting for hundreds of thousands of visitors since it was built.

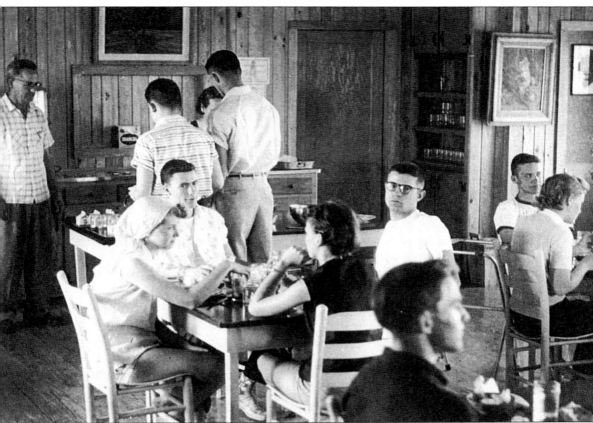

Harvie Lybrand supervises the serving in the Ocean Villa dining room. The active outdoor life of swimming and fishing can make a fellow quite hungry.

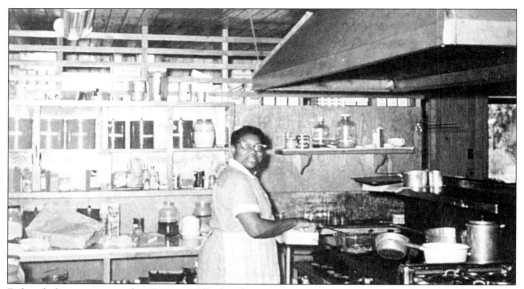

Behind the scenes in the Ocean Villa kitchen, preparations are in order for one of the great meals to be served in the dining room to the lucky boarders. Shown here at the stove is Janie Green Parker, beloved by many not only for her wonderful kitchen skills, but also for the humor served with her creations.

A couple on the steps of the Edisto bowling alley do what comes naturally to visitors and residents of Edisto since time began. We don't know their names, but we do wonder if they finished out the course, married, had children, and now entertain their "grans" at Edisto as countless other generations have done and continue to do.